# Nancy Graves: A Survey 1969/1980

# Nancy Graves: A Survey 1969/1980

Essay by Linda L. Cathcart

Albright-Knox Art Gallery, Buffalo, New York

This exhibition was organized for the Albright-Knox Art
Gallery by Linda L. Cathcart. The exhibition is coordinated by Douglas G. Schultz.

## Exhibition Schedule

Albright-Knox Art Gallery, Buffalo, New York
May 3 - June 15, 1980

Akron Art Institute, Akron, Ohio
July 5 - August 31, 1980

Contemporary Arts Museum, Houston, Texas
September 20 - October 26, 1980

Brooks Memorial Art Gallery, Memphis, Tennessee
November 15, 1980 - January 6, 1981

Neuberger Museum, State University of New York
College at Purchase, Purchase, New York
January 25 - March 15, 1981

Des Moines Art Center, Des Moines, Iowa
March 30 - May 3, 1981

Walker Art Center, Minneapolis, Minnesota
May 31 - July 12, 1981

This exhibition, *Nancy Graves: A Survey 1969/1980,*
has been made possible by a grant from the National
Endowment for the Arts, Washington, D. C., a federal
agency. In Buffalo, this exhibition is also supported by a
grant from the New York State Council on the Arts. In
Houston, this exhibition is supported by grants from the
National Endowment for the Arts, the Texas Commission
on the Arts, and is made possible in part by the
Cultural Arts Council of Houston and Shell Companies
Foundation, Incorporated.

Copyright © 1980      The Buffalo Fine Arts Academy
All rights reserved
Library of Congress Cataloging in Publication Data
Albright-Knox Art Gallery
Nancy Graves: A Survey 1969/1980
Bibliography: p. 102
1. Graves, Nancy Stevenson, 1940-          — Exhibitions.
I. Cathcart, Linda L.
N6537.G69A4   1980          709'.2'4          80-13227
ISBN 0-914782-34-7

cover: Nancy Graves. **Calipers, Legs, Lines,** 1979. Acrylic and oil on
canvas, 64 x 88". Private collection, courtesy William Zierler,
Inc., New York. Photograph courtesy M. Knoedler & Co., Inc.,
New York.

# Contents

## Foreword

Nancy Graves literally stunned the art world with the creation of her *Camels* in 1967 - 69. With these works and those that followed, she has continued to investigate a naturalistic and universal formalism in sculpture, painting and drawing, entirely singular in direction and, of course, representing her own unique artistic temperament. The odyssey of her creative moves is her own intuitive strength and, already several years ago, was noted as a promise of future excellence. This exhibition will demonstrate to the viewer her achievement; a creative production of art during the past eleven years that only a handful of contemporary artists could hope to equal and which has earned for Graves the admiration of curators, critics and collectors on several continents.

Shortly after the *Camels* were created, three of them were displayed at the Whitney Museum of American Art in New York and were quickly acquired by the National Gallery of Canada in Ottawa. Others have subsequently been destroyed or have passed into European hands. Thus, with the removal of these works, American art interests find, perhaps for the first time, a provocative and seminal period at the threshhold of an artist's maturity entirely absent from collections in this country. Certainly this is

just a beginning for us, of situations long suffered by others elsewhere. Hence, we are especially grateful to Hsio-Yen Shih and Brydon Smith of the National Gallery of Canada for the loan of *Camel VI* to the exhibition.

We at the Albright-Knox Art Gallery are fortunate to possess three works by Graves; a painting of major importance entitled *Camouflage Series #5*, 1971 - 74, and two works on paper, *Grand Canyon of Mars – 5000 kilometers along the Martian Equator*, 1973, and *Weke*, 1977. Given the duration of commitment to her work in Buffalo, it is especially appropriate that this first retrospective presented in American museums be undertaken by the Gallery, in association with Linda L. Cathcart, Director of the Contemporary Arts Museum of Houston, assisted by the Gallery's Chief Curator, Douglas G. Schultz. Ms. Cathcart has, in her essay, contributed a valuable analysis and critical appraisal of Graves' several very rich, productive periods.

I am grateful to Ms. Cathcart and Mr. Schultz for their diligence and for their contributions to the project. Josephine Novak has ably performed her duties as editor of this publication, discharged at times under exceedingly difficult deadlines and circumstances. Bud Jacobs, of the State University of New York at Buffalo School of Architecture and Environmental Design, designed the catalogue. I wish to thank the Gallery's Registrar, Jane Nitterauer, and our Curatorial Secretary, Norma Bardo, for their many special efforts for the exhibition. Many of the staff of the Contemporary Arts Museum in Houston aided Ms. Cathcart in preparing the initial manuscript.

We wish to express our acknowledgment of the importance of the support for this project provided by the National Endowment for the Arts and the New York State Council on the Arts. The participating museums and their respective Directors and Boards are a crucial element in realizing a large exhibition like this, and we are indebted to them.

Finally, the artist herself has aided and cooperated in every way during the long, involved process of organization. Moreover, she has created a superb print especially commemorating the exhibition and an astonishingly beautiful image for the exhibition poster, summarizing a decade of her principal artistic concerns. I express my sincerest and warmest thanks to her as a friend and my unbounded admiration as a museum director.

Robert T. Buck
Director
Albright-Knox Art Gallery

## Acknowledgments

The task of organizing this exhibition and its accompanying catalogue was accomplished jointly by the staffs of the Albright-Knox Art Gallery, Buffalo and the Contemporary Arts Museum, Houston. The staffs of both institutions contributed their special skills and talents to bring this exhibition to fruition and they deserve special and grateful acknowledgment. We are indebted to Douglas G. Schultz, Chief Curator, Albright-Knox Art Gallery, who coordinated the presentation of the exhibition and ably oversaw the catalogue and poster production. Robert T. Buck, Director, Albright-Knox Art Gallery, lent his support and encouragement throughout. We would also like to thank Josephine Novak, who edited and supervised the production of this catalogue and Bud Jacobs, who designed it. At the Albright-Knox Art Gallery, Serena Rattazzi, Coordinator of Public Relations, Jane Nitterauer, Registrar and Norma Bardo, Curatorial Secretary, worked hard to ensure the success of this exhibition. In Houston, Marti Mayo, Emily Todd, Pat Pfeffer and Joan Baird worked to accomplish the organization of much information and many details necessary to this presentation.

We gratefully acknowledge the assistance of the staffs of M. Knoedler & Co. Inc., in New York, particularly Ann Freedman, Marian Moffett and Margaret Poser, and the Janie C. Lee Gallery, Houston, for their assistance throughout. Joan Seeman in Houston also donated valuable manuscript material. Laura Justice Fleischmann, who compiled all the catalogue documentation, spending many long hours with Nancy Graves and in the library, deserves special mention.

Thanks to Beatrice Mady and Tom Butter, who assisted Nancy Graves in her studio. Nancy Graves, whose endless patience and generosity match her abilities as an artist, deserves our warmest gratitude and appreciation and, finally, so do the lenders to this exhibition, who have participated with generosity and enthusiasm.

Linda L. Cathcart

## Lenders to the Exhibition

Mr. and Mrs. Jay I. Bennett
Mr. and Mrs. Norman Braman
Mr. and Mrs. H. Christopher J. Brumder
Lisa Negley Dorn
Sawnie Ferguson
First City National Bank, Houston
Joel and Paula Friedland
Nancy Graves, New York
Mr. Graham Gund, Boston
Helen Elizabeth Hill Trust, Houston
Wilhelmina and Wallace Holladay
Mr. and Mrs. Larry Horner, Los Angeles
Mr. and Mrs. Robert Kardon
Mr. and Mrs. Laurence Kramer
Mr. and Mrs. Mark Lederman, New York
Janie C. Lee
Carol Lindsley
Mr. and Mrs. Ezra P. Mager
Mr. and Mrs. Fulton Murray, Dallas
Mary S. Myers
Dr. and Mrs. Edward Okun
David and Marilyn Reichert
Dr. and Mrs. Charles Schneider
Skinner Corporation
University of Texas at Dallas
Private Collection, courtesy William Zierler, Inc., New York
Private Collections

Albright-Knox Art Gallery, Buffalo, New York
Brooks Memorial Art Gallery, Memphis, Tennessee
Dallas Museum of Fine Arts, Dallas, Texas
Des Moines Art Center, Des Moines, Iowa
La Jolla Museum of Contemporary Art, La Jolla, California
The Museum of Fine Arts, Houston, Texas
National Gallery of Canada, Ottawa

M. Knoedler & Co., Inc., New York
Janie C. Lee Gallery

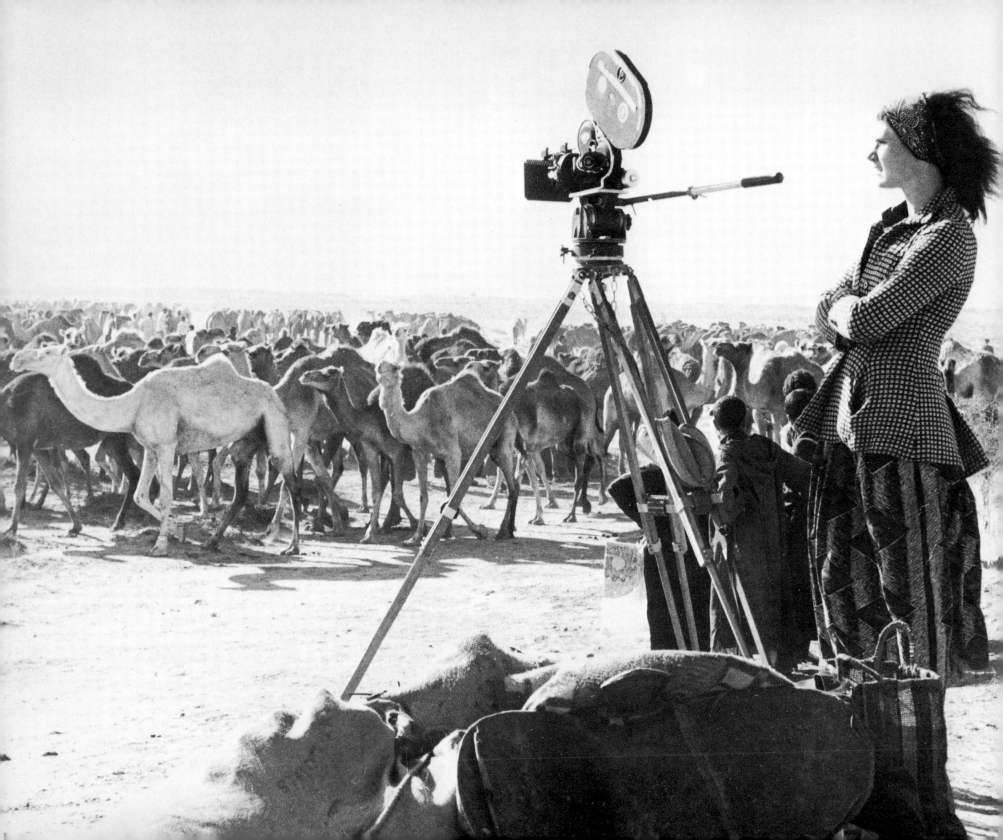

# Nancy Graves: A Survey 1969/1980

Linda L. Cathcart

Nancy Stevenson Graves was born in Pittsfield, Massachusetts on December 23, 1940. In 1961, she graduated from Vassar College with a degree in English literature. She received a second undergraduate degree and a Master of Fine Arts from the School of Art and Architecture at Yale in 1964. Working as a painter, she was awarded a Fulbright-Hayes Fellowship in 1965 to study in Paris for a year. This was followed by a year in Florence and, at the end of 1966, she moved to New York City where she continues to live and work.

Encouraged from an early age by her family, Nancy Graves explored various disciplines as a matter of intellectual necessity. Her vision as an artist has never been a particularly singular one and is perhaps more easily understood by knowing her intense curiosity for many subjects, particularly science and natural history. Growing up in the country she enjoyed observing nature. She had access in Massachusetts to an art and natural history museum which she recalls visiting with her family.

Graves, who attended art classes as an after-school activity during the primary grades, felt from the age of twelve that she wanted to be an artist. She went to Vassar where she thought there would be a strong program in the applied arts. She found the main emphasis was on the history of art and she subsequently switched to the study of literature.

In 1961, Graves entered Yale where she spent three years learning the techniques of art-making. She recalls that the paintings she made at that time ranged from still lifes to Fauvist-inspired abstractions. The Abstract Expressionist influence of her teachers, the courses of Josef Albers, the paintings of Matisse, the sculpture of Brancusi, converged with Pop Art, which was emerging in New York, to influence her thinking.

During her year in Paris, Graves continued to study the European masters. She found, however, that the only contemporary art that interested her was made by Americans. She cites the work of David Smith, Claes Oldenburg and Bruce Nauman as influences. Smith, whose work had a powerful impact on all American sculptors, was of particular interest to her because of his use of organic forms; Oldenburg, because he was using soft materials and large scale; Nauman, for his use of unusual materials — fiberglass, plaster, neon and other non-art materials — and his seeming ability to make "something out of nothing."

At this time, Graves began to explore three-dimensional possibilities by using various materials put together in different ways. Graves, the composer Philip Glass and the artist Richard Serra (to whom Graves was married from 1965 to 1970), were all in Europe at the same time and exchanged ideas. After returning to New York City, they continued to explore the possibilities of series, altered placement, and repetition and variation of forms for both music and art.

In 1965, Graves went to Florence where she lived and worked for another year. It was then that her interest in sculpture matured. She felt that sculpture had more pos-

sibilities than painting and that it was the most appropriate medium for her ideas. She stopped painting, although she was to return to it later, and began making sculpture in earnest. It is important to note, however, that while Graves made no paintings between 1966 and 1971, she continued to draw throughout this period. Many of these drawings employ color and some are actually paintings on paper.

During this period, Graves became aware of the work of an 18th century anatomist named Susini whose investigations of form in wax she saw in the natural history museum in Florence. These life-size investigations were based on two sources, animal and human anatomy. His total work had about it a completeness and an aesthetic which she admired and which she felt transcended the subject matter.

Graves, who related to the technical and visual problems of display in the context of the natural history museum, decided to base her art on a form from nature. She wanted an image which had not been explored in Western art and she chose the camel for its size and softness, its enigmatic quality and its potential as metaphor. Her camels were to be life-size and realistic in appearance. Because she wanted to work without assistance, she chose not to use steel or other heavy and difficult materials. Graves spent three months studying carpentry in order to devise a method for making camel armatures. She made wooden armatures filled out with polyurethane and burlap which were covered with real animal skins transformed by cutting and painting with oil paint. The eyes and occasionally the teeth were the only elements not actually fabricated by the artist. When Graves chose an image, she carefully researched both the form and technical skills and invented the techniques necessary to realize it to her satisfaction.

Fig. no. 1. Left to right:
**Camel VIII, Camel VI and Camel VII,** 1969
wood, steel, burlap, polyurethane, skin, wax and oil
**Camel VI,** 90 x 144 x 48"
**Camel VII,** 96 x 108 x 48"
**Camel VIII,** 90 x 120 x 48"
Collection National Gallery of Canada, Ottawa
Gifts of Mr. Allan Bronfman, Montreal

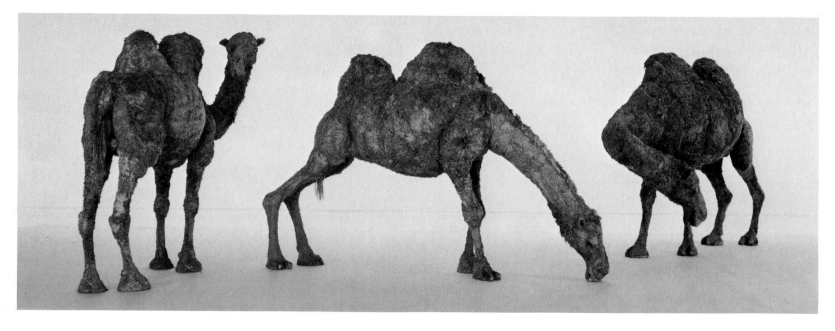

NOTE: Works illustrated in this essay, with the exception of Camel VI, are not included in the exhibition.

Graves pursued her research on the camels in libraries, museums, slaughterhouses, in the desert and in the marketplace. From 1968 through 1971 she used anatomy and archaeology as points of departure from which she could make her way as an artist. She felt that it was necessary to know more about the physical structure of the animals in order to know more about their possibilities for contemporary sculpture. Her early sculpture not only transposed information but also forced a unique dialogue between form and technique. Her work acknowledged the systems that provided her with visual material. Graves was concerned with metaphor, not with duplication; she was interested in how real and physical forms are perceived and, further, in how these forms could be abstracted.

*"The degree of surface incident articulated in my camels has different dimensions from the camels in the 'real world.' The work refers only to itself, making the idea of similar objects being equal or replicas irrelevant to my concern . . . . I cannot imagine or perceive a camel until it is completed."* [1]

In 1966, Graves moved to New York City. She made three camels (subsequently destroyed) during 1967-68. She first exhibited them in New York at the Graham Gallery in 1968. Between 1968 and 1969 Graves made four more camels, three of which were exhibited in the Whitney Museum of American Art in New York in March-April of 1969. Curator Marcia Tucker wrote of *Camel VI* (Cat. no. 1), *Camel VII* and *Camel VIII* (Fig. no. 1):

*"By virtue of their animate quality and the gesture of interrupted motion, these works deal directly with perceptual problems of illusion and reality. All realistic sculpture has, in the past, alluded to a model. In making camels, however, the artist has abandoned traditional concepts in order to replicate a living form which is unaware of its function as a model. Since no fixed (or posed) position will approximate the final work, each camel*

1  Marcia Tucker, "Nancy Graves: Camels." (New York: Whitney Museum of American Art, 1969), n.p.

Fig. no. 2
**Calipers,** 1970
¼" steel rods, 12 x 180 x 120"
Collection of the artist

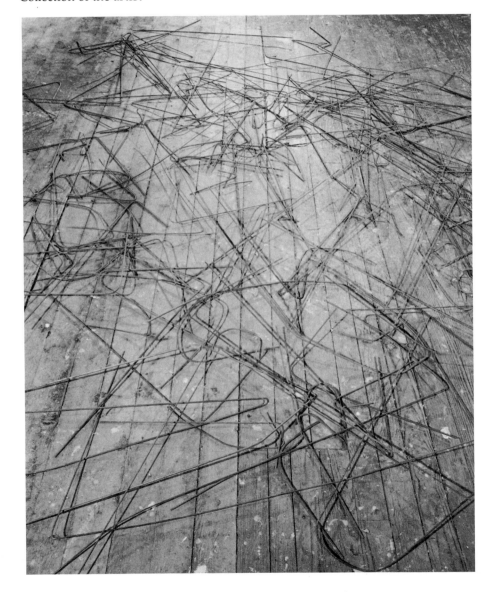

*comes into being upon its completion by the artist. Each work alludes only to itself and becomes its own illusion."*[2]

Generally, the exhibitions of the camels were received with bewilderment. Brenda Richardson later wrote an article on Graves' work which sheds some light on this response:

*"Graves is concerned with the de-differentiated field in which formation and abstraction are no longer antithetical, regardless of the medium. Traditionally, these two approaches to art, at least in America, have been polarities, and when there has been an attempt to join the two, one or the other has clearly dominated. Graves's initial attempts to realize this formalistic position were in fact successful — the camels from 1969 were strong statements of abstract surface and volume in space. Nonetheless, the very fact of their quasi-realistic presentation and the extensive degree to which they allowed anthropomorphic interpretations and varying contextual responses virtually precluded for most viewers any but the most literal (and representational) analysis."*[3]

Between 1969 and 1971 Graves made a number of works using camel bones. The bone forms were made out of sculpted wax formed over a steel-rod armature and colored with marble dust and acrylic paint. Graves had stripped the camels to reveal other aspects of the subject.

*"By going inside and using the bones as a point of departure or illusion, I was questioning a post-Brancusi, post-Andre, late '60s notion of armature."*[4]

*Miocene Skeleton from Agate Springs, Nebraska,* 1969, and *Vertebral Column with Skull and Pelvis,* 1970, are two camel skeletal forms presented in logical or actual sequence revealing the internal structure of the camel not visible in nature or in her other camel works.

2   Ibid.
3   Brenda Richardson, "Nancy Graves: A New Way of Seeing." *Arts Magazine* (New York), Vol. 46, No. 6, April 1972, p. 58.
4   Nancy Graves in conversation with Linda Cathcart (New York, March 23, 1980).

To make these camel forms, Graves explored the logic of traditional viewing presentation. She made a careful study of base, armature, weight and gravity, but at the same time she began to realize the possibilities of other methods of presentation, such as propping, hanging and scattering. This further generated ideas about internal versus external forms; placement versus displacement; and the way known, as opposed to abstract images demand attention.

*Vertebral Column* hangs from the ceiling and thus eliminates the need for a traditional base. In *Fossils,* 1970 (Cat. no. 3) and *Inside-Outside,* 1970 (Fig. no. 3) the bones are scattered in a non-logical sequence, using the floor as a base. All three stress the importance of sculpture as an object seen from various positions and experienced in time. Specifically, *Inside-Outside* is half a camel skeleton that has been segmented. Each skeletal section lies inside a complementary form. The eye can reassemble the skeleton and replace the exterior covering to re-form the original camel shape.

The most abstract and complex of the skeletal sculptures is *Calipers,* 1970 (Fig. no. 2). It consists of one-quarter-inch steel rods scattered and overlapped on the floor. The rods, previously used as armature, now became the sculpture. As the title implies, each rod refers to measurement. In this case, what is being measured is the distance between the ribs of a camel. With time the rods rusted, leaving their outline on the floor. The rust marks reminded Graves of shadow which could function as measurement and drawing. Graves would use a physical manifestation of shadow in the next works.

The earth which contains fossils also contains the objects of earlier cultures (see Fig. no. 4). In the sculpture done between 1970 and 1971, Graves placed camel bones and skins in another format, based on the totemic and shamanistic forms of primitive hunting societies. Ritualistic forms often refer to cycles of life and death, day and night, light and dark. These cycles were connected for Graves to her sculptural transformation of actual camels to fossils and finally to literal shadows.

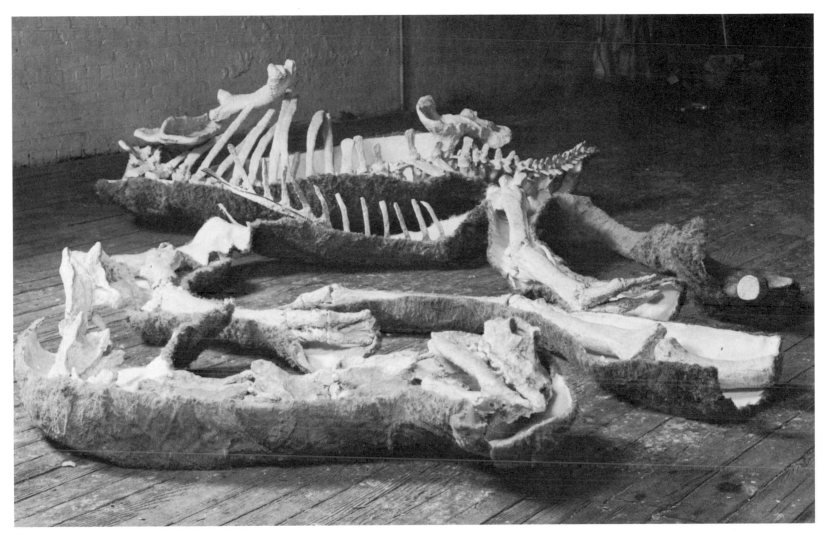

Fig. no. 3
**Inside-Outside,** 1970
steel, wax, marble dust, acrylic, fiberglass, animal
skin and oil, 48 x 120 x 120"
Collection of the artist

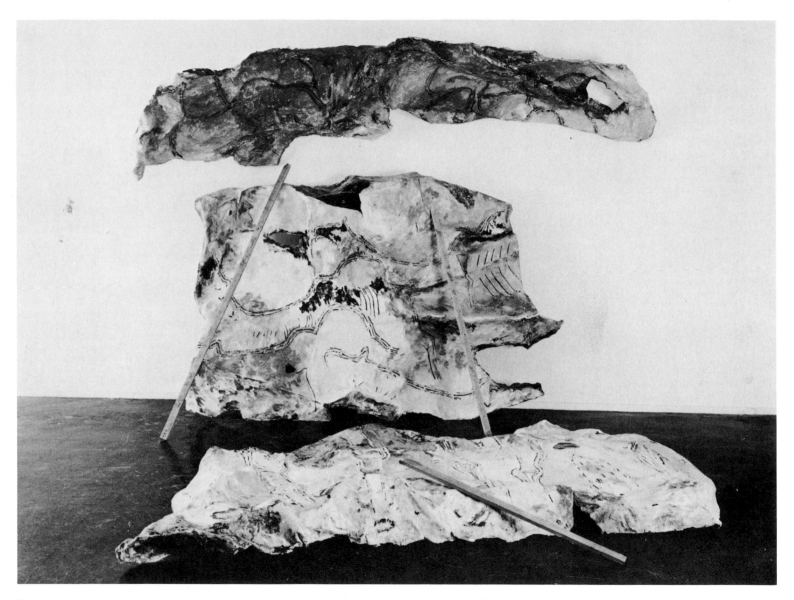

Fig. no. 4
**Paleo-Indian Cave Painting, Southwestern Arizona,
In Position For Installation,** 1971
(To Dr. Wolfgang Becker)
steel, fiberglass, oil and acrylic, 156 x 108 x 90"
Collection Neue Galerie im Alten Kurhaus,
Aachen, West Germany

Fig. no. 5
**Fifty Hair Bones and Sun Disc,** 1971
(To the Students of the Werkkunstschule,
Aachen)
steel, marble dust and acrylic, 132 x 156 x 156″
Collection Museum des 20. Jahrhunderts, Hahn
Collection, Vienna

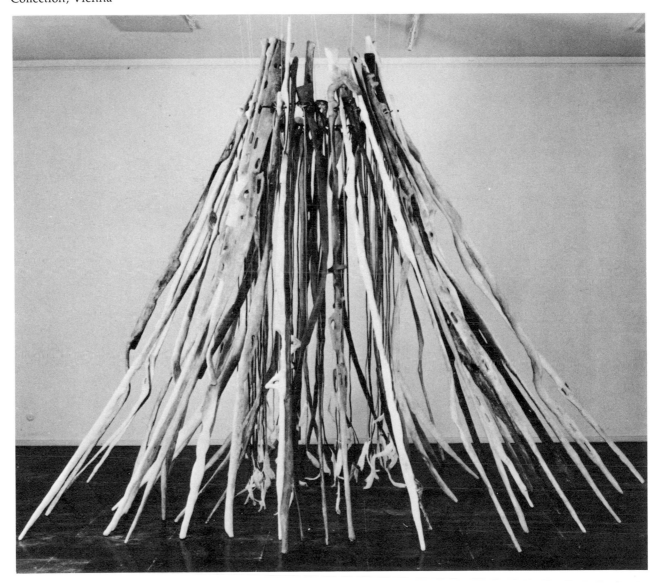

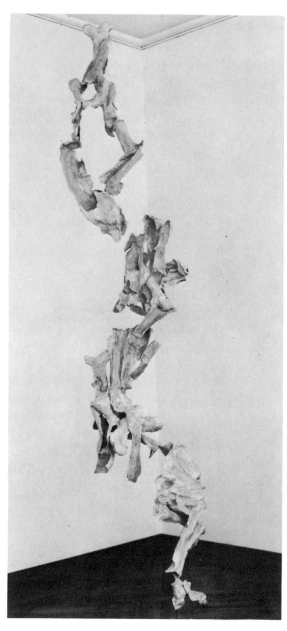

Fig. no. 6
**Cast Shadow Reflecting from Four Sides,** 1970
gauze, acrylic and marble dust, 132 x 40 x 36"
Collection of the artist

*Shadows Reflecting and Sun Disks*, 1970, *Cast Shadow Reflecting from Four Sides*, 1970 (Fig. no. 6), *Shaman, 1970* (Fig. no. 7) and *Variability and Repetition of Variable Forms*, 1971 (Fig. no. 8) were all large, free-hanging, multi-part, colored objects. In *Shadows Reflecting and Sun Disks* the elements represent shadows and their source. The two steel hoops (sun disks) are empty and the suspended gauze strips (manifestations of shadows) are translucent, contradictory to what they represent. A related work, *Fifty Hair Bones and Sun Disk*, 1971 (Fig. no. 5) is a great tepee of plaster, glue and acrylic paint over steel rods. The bones (shadows) meet at a central hoop (sun) implying the direct connection between sun and shadow. *Shaman* and *Variability and Repetition of Variable Forms* are the most ambitious of the group. They consist of multiple elements, each one a highly-colored, fragile object. They are shadowy anthropomorphic forms hovering against the wall, creating a drawing in space.

The contours of the camels and the linear qualities of sculpture like *Shaman*, together with two films, studied drawing in three dimensions. *Goulimine*, 1970 (16mm/8 min./color/sound) and *Izy Boukir*, 1971 (16mm/20 min./color/sound) were made in Morocco and recorded the repetition and variance of camels as they moved singly and in caravan.

Graves made the sculpture *Variability of Similar Forms* in 1970 (Cat. no. 5) after the first of the two camel films. It consists of thirty-six free-standing, life-size skeleton camel legs. It suggests a static rendering of the movement studied in the film. Time, placement and pattern were considerations that Graves brought to bear on her work in each medium. Moving between media she translated the information in each case from one dimension into another — a process of working that continues to the present. Graves acknowledges that her thinking on perception and recognition owed a debt to the work of the photographer Eadweard Muybridge (see Fig. no. 9) and to the writers Camus, Robbe-Grillet and Ortega y Gasset.

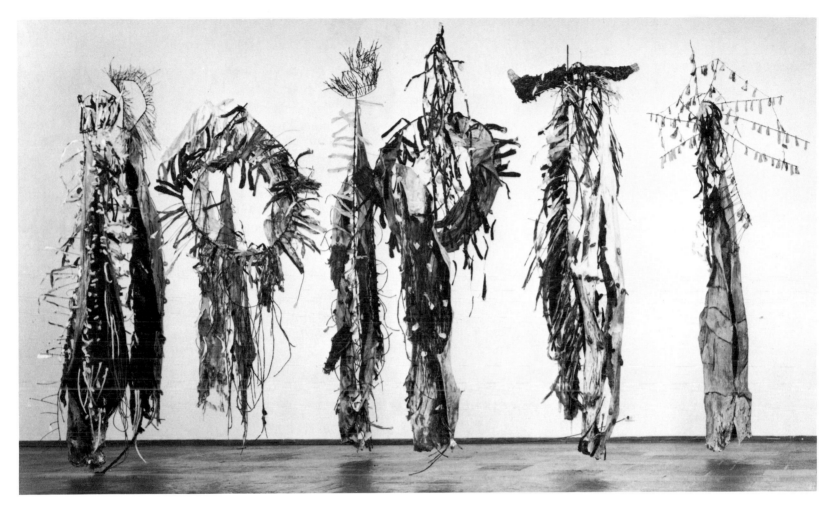

Fig. no. 7
**Shaman,** 1970
steel, latex, gauze, oil, marble dust and acrylic,
144 x 168 x 168"
Wallraf-Richartz Museum, Ludwig Collection,
Cologne, West Germany

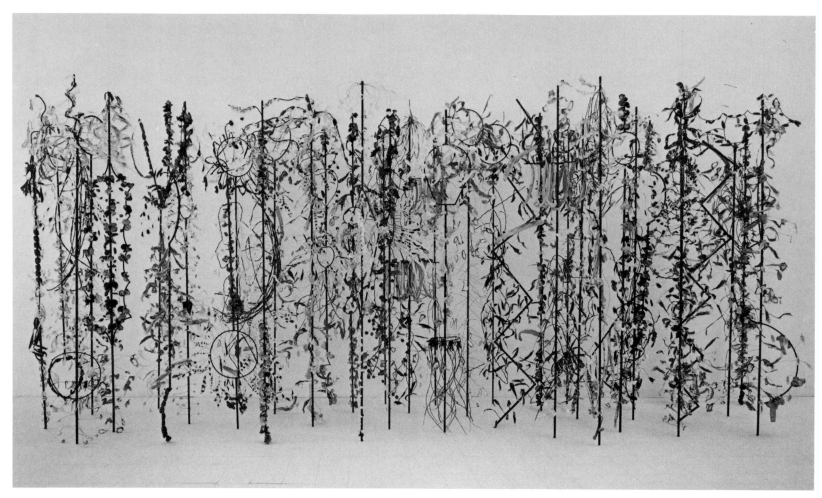

Fig. no. 8
**Variability and Repetition of Variable Forms,** 1971
steel, marble dust, acrylic, wax, gauze, latex and oil,
120 x 312 x 160"
Collection National Gallery of Canada, Ottawa

There are a number of important drawings from 1970-71 which were two-dimensional translations of the ideas with which Graves was working in sculpture and in film. *Izy Boukir Caravan 7, 16 June, 1970, Morocco,* 1970, is a drawing done in a notebook that Graves kept while filming. On the left, it has written notes for camera placement and editing. In the center are juxtaposed the outlines of camels and the patterns of paths of the camel caravans. Put together on the page these two images make a pattern that reads abstractly. *Signs Exchanged Between Ireteba, Sub-Chief of the Mojave, and Major Beale, Aboard the "General Jessup," While Ferrying 16 Camels (Property of the U.S. Government) Across the Colorado River Near Needles, California, January 1858,* 1970 (Cat. no. 4) is a diagram, a specific transposition of information. Arrested on paper, however, the motions of the signals have a rhythm and flow which create a back and forth pattern. In several other drawings, Graves explored shape and pattern as well as methods of color application. *Interaction Between Bullhead Strangers,* 1971 (Cat. no. 7) and *Lady Bug Beetle Swarm/Wintering in California,* 1971 (Cat. no. 8) are gouaches on paper, representing animal subject matter by dots of color. She subsequently used this method in a series of paintings on canvas.

In 1972 Graves discontinued her sculpture and returned to painting. Her new works were informed by both the colored sculpture and the recent drawings. Called the camouflage series, the paintings were of various sea animals. Camouflage as a technique of coloration is a natural phenomenon which alters or obscures perception. It is achieved either by changes in pattern or in color. The paintings were made by an overall pattern of dots of painted color. In the catalogue to accompany an exhibition of these and later lunar and Mars pictures which employed the same surface technique, Jay Belloli observed:

*"The individual strokes were separated and placed on a flat ground so that they visually created a feeling of depth, implying space both in front and in back of the surface. The fragmentation of the subjects into dots allowed them to retain their figurative aspects and, in addition, created an almost abstract continuum across the canvas."*[5]

In *Camouflage Series #5,* 1971-74 (Cat. no. 6) the fish forms are all but obscured by the dot pattern of a single hue. Though hidden, the forms are discernible at a certain distance. Varying densities of dots are used to suggest relief but they also encourage the reading of fragmented forms as an abstract pattern of color and line and motion.

Camouflage, like shadow, appealed to Graves because it implied the abstraction of a natural form. By removing ideas and images from context, Graves allows the viewer to form a deeper relationship with the information. Her concern is not to remove a thing from its own arena in order to examine it alone, but instead, to re-evaluate the way one sees and how one can accomplish a mental completeness of complex images.

Following the camouflage series were six paintings made in 1972 from bathymetric and topographic maps. They depicted portions of ocean floors and were titled accordingly. In *Indian Ocean Floor I,* 1972 (Cat. no. 16) Graves used a dense pattern of almost-connected dots to form lines which curve around the canvas to trace the topography. Each color and each dot was carefully chosen and applied; Graves did not permit random incident in their making. Up close, the painting surface is rather flat, but seen from a distance, it has a shimmering quality. The picture is somewhat severe in space and motion and it has a controlled energy.

The fact that the original bathymetric maps were made of dot patterns, used in off-set lithography to indicate varying degrees of depth, was visually appropriate. Graves' positive response to the pre-existing map material was intuitive:

*"It is only possible for me to select . . . an image . . . if I have a way of interpreting it, if I have in the back of my head or already*

5   Jay Belloli, "Nancy Graves." (La Jolla: La Jolla Museum of Contemporary Art, 1973), p. 5.

*worked out some kind of sketch or form-making process that I can impose upon this material. When I go about seeking or selecting certain kinds of images, they have to adapt themselves to the selective process; art is the primary process. Very often in painting, the material gives back something — there will be unexpected changes in the form or in the style that is imposed upon these early decisions relative to content. But the content must adapt itself to my concerns which are primarily those of creating a new way of seeing.''*[6]

Not only was the method of making maps relevant, but maps themselves coincided with her intentions to extract and abstract visual information. Her process of creating is cumulative in the same way that the system of map making is additive. Both imply extended information. Maps are devices which allow us to perceive areas which are too large to be encompassed by our vision. They prove the existence of and provide a visual equivalent for an experience which can only be perceived through time and travel and then never completely.

Graves' thinking process is associative. Camels exist in nature, the bones are fossilized in the ground; the earth holds archaeological evidence as well as geological information. The ocean floor is a record of geological history and the ocean is a natural environment for animals. It is, like the earth and the planets, the subject of maps.

*"One of the logical points in the sculpture is that the content had to do with prehistoric forms such as fossils, archaeological evidence and used this as a line from which to extend three-dimensional form into two dimensions. Ultimately, I devised mapping in terms of its furthest abstractions to be the point of departure for various series of paintings. One was the ocean floor series which meant that I was again thinking about the earth as a prehistoric form. The earth contains fossil information, the ocean floors being one source. Then I moved into the moon, which was not only poetically but scientifically, con-*

*sidered to be a fossil of the earth . . . and then began to consider anything that had been made by man which was a system in two dimensions as a possible point of departure for my concerns which would then continue to fall into the category of mapping.''*[7]

In addition to the camouflage and bathymetric paintings, in 1972 Graves made a set of eight lunar pictures and ten drawings inspired by geologic discoveries about the moon which had been superimposed on satellite photographs by means of color which was arbitrary but the key to a system. Besides the process of selecting images she began to transpose and overlay images in these pictures while developing color patterns. Graves posed for herself the problem of relating a single color to the information in each of the lunar paintings. Unlike the earlier paintings where color was related precisely to object, in the lunar series, color had to be imposed because none was inherent in the natural form. *Part, of Sabine D. Region of the Moon, Southwest Mare Tranquilitatis,* 1972 (Cat. no. 20) uses yellow as the thematic color. Each horizontal scan line is in yellow. Scan lines were a part of the satellite photographs. They were the basis of the grid-like structure in the paintings which holds the images together. In some of the pictures there are areas of unpainted canvas which recall the three dimensions of the source material by use of profile of pattern against negative space. In *Montes Apenninus Region of the Moon,* 1972 (Cat. no. 18) the image is roughly divided diagonally from upper right to lower left into blue and red areas. These are two areas of blank canvas which emphasize the derivation and transformation of information taken from a plan.

*Nearside of the Moon 20° N-S x 70° E-W,* 1972 (Cat. no. 19) from this series, was Graves' largest work to date. Consisting of four joined panels, the painting is eight feet high by twenty-four feet wide.
*"In addition to summarizing much of the type of material she had used in her earlier lunar paintings, she made the 4-section canvas*

6   Joan Seeman, interview with Nancy Graves (New York, June 6, 1979), unpublished.

7   Ibid.

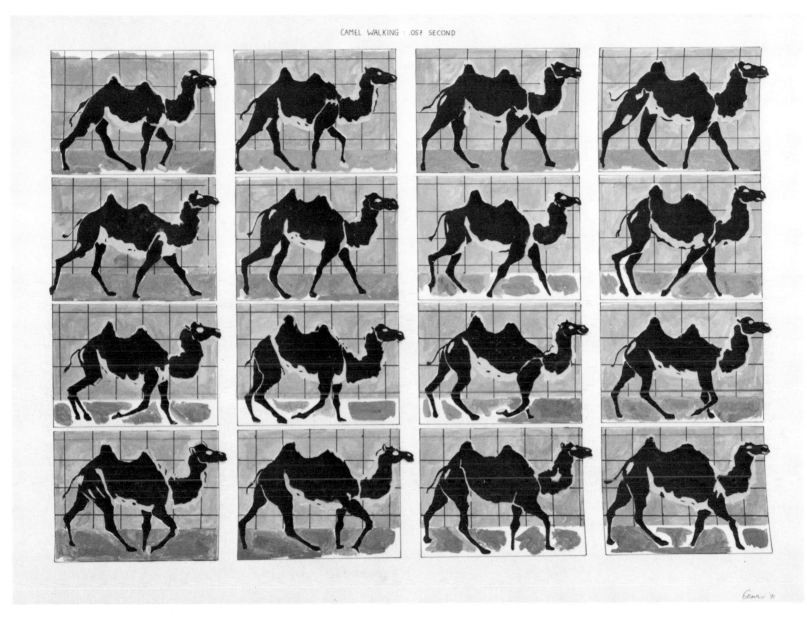

CAMEL WALKING : .057 SECOND

Fig. no. 9
**Camel Walking (.057 Sec.) After Muybridge,** 1971
gouache on paper, 20 x 30"
Collection Neue Galerie im Alten Kurhaus,
Aachen, West Germany

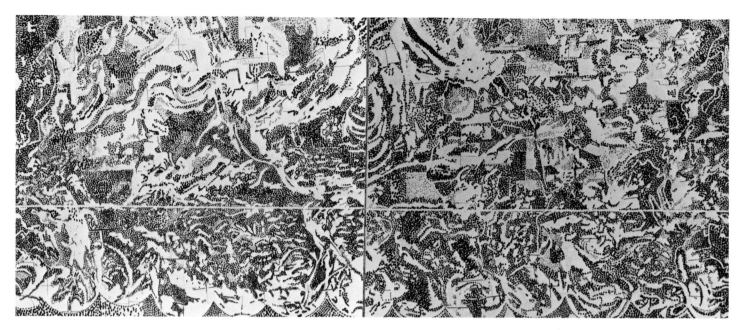

Fig. no. 10
**First Look at the World's Weather,** 1973
gouache on paper, 22½ x 60" (2 panels 22½ x 30" each)
Collection of the artist

*a composite of various kinds of mapping that existed on the moon during this century, an action that required an extraordinary amount of research. For example, linear forms based on the lunar map by Wilkins were included as a homage. Material based on sequential photographs taken by a satellite which impacted on the lunar surface was also included as well as small rectangles in the right-hand panel which were based on computer and video interpretations of the moon. The inclusion of different types of mapping meant the combination of what were in fact, different ways of seeing the same terrain. All decisions in this regard were compositional ones, and many compositional devices not included in earlier paintings were added."*[8]

The trajectory pattern of the Apollo orbit is represented on the canvas by an undulating line that serves to unify the

parts of the painting. The curved forms at either end of the canvas act to enclose the image and create four empty corners that recall the incompleteness of the information as well as the impossibility of rendering completely a three-dimensional object in two dimensions.

Graves looked at actual scientific data gathered by the Mariner 9 satellite at the Jet Propulsion Laboratory in California where several thousand images were on file. She collected images for the painting *Mars*, 1973, another large, four-panel painting. In *Mars*, the information is highly abstracted and predominantly black and white, indicating that less is known about Mars. In *Near Side of the Moon . . . ,* Graves had indicated the more extensive scope of material by using color and recognizable elements. Black squares superimposed throughout the four panels of *Mars* indicate technical failure, noise, or uncharted areas for which no

8   Belloli, p. 6.

information existed. These dense areas are included as formal devices making negative shapes which, in other works, are found as shadow or blank canvas.

In 1973-74, Graves made a group of shaped paintings; an untitled series based on satellite-relayed weather photographs of nimbus cloud formations. Using modular panels, Graves transposed, redefined and abstracted information another step by physically shifting the perimeters of the paintings. The result was a complicated play of figure and ground through positive and negative space. The overlapped images in the paintings created patterns, as well as dictating the actual shapes of related modules. Each unit of the painting became a figure on the ground of the wall.

*Untitled #6, White,* 1974 (Cat. no. 31) is made up of rectangular bars hung diagonally on the wall in five segments. The ground of pale dots is punctuated by larger circles of brighter color which tie together both the surface and the separate panels. *Untitled #1, Green,* 1973 (Cat. no. 29) is a less complex shape covered with a boldly painted pattern. Shifts in scale are indicated by changes in both color and in gesture. Finally, Graves found that the wall showing between the panels could not be sufficiently controlled as part of the painting.

For Graves, 1973-74 was a period of exploration. Instead of continuing to push the formal internal elements of painting to influence external shape, she moved in the opposite direction. The external gesture would come into play on the internal structure. *First Look at the World's Weather,* 1973 (Fig. no. 10) a gouache and ink on paper, and *Hurricane Camille,* 1973 (Cat. no. 25) India ink and acrylic on paper, treated the internal and overall configuration in much the same way as would the later canvases. Forms swirl towards the edges of the paper, particularly at the bottom where they curve back up into the center.

While *First Look* . . . is done in an overall dot pattern, *Camille* is an image made with bold gestural color over which is imposed a white grid. The drawings both use separate and familiar techniques, but both give indications of a change in composition that would effect a change in subsequent work. But in the meantime, in 1975, previous styles and techniques came together in a painting on a grand scale. *Painting U.S.A.,* 1975 (Fig. no. 11) in five panels, is an aerial survey map in the same large scale as *Mars* and *Near Side of the Moon* . . . . Here, however, the joined panels read as individual segments. The focus shifts from a large view on the left towards detail on the right and the central panel is an abstraction of the detailed information. This abstraction looks like the paintings of 1976, where forms concentrate in the center of the canvas; it has an open composition similar to *First Look* . . . and *Hurricane Camille.*

Pastels on paper from 1976 like *Bish,* 1976 (Cat. no. 33) and *Yot K. Series,* 1976 (Cat. no. 35) moved further away from the previous geologic references to the moon; they referred to the works of 1972. Color was no longer applied evenly to be descriptive and structural. It was put down in a variety of expressive ways. The associations of form and color were less specific and more random. Thomas B. Hess, in a review of this work, wrote:

*"The pastel has everything to do with the maps, yet it differs enormously, point by point. It seizes a gestalt – a bundle of key peculiarities."* [9]

In 1973, Graves began the film, *Aves: Magnificent Frigate Bird, Great Flamingo* (16mm/23 min./color/sound) which took two years to complete. The film is a study of the flight motion of the frigate bird and the flamingo. It is divided into three sections by color — pink, black and white, similar to the lunar paintings, each of which were about a different color. Recording the bird profiles and flight patterns, the film combines color and pattern in a lyrical expression of form. Another film, *Reflections on the Moon,* 1974, is a complement to the lunar and weather paintings in the same way.

9   Thomas B. Hess, "Feel of Flying." *New York* (New York), February 28, 1977, p. 58.

*"[This film] explores as black and white abstraction the passage of motion picture over a static surface comprised of two hundred odd stills of the lunar surface. Film sequences are structured by camera motion over the field by reversing the filmed image, by inversion of the static image, by the use of the zoom, the pull back, and, from top to bottom and reverse, left to right and reverse . . ."*[10]

This film, along with *Aves, Goulimine* and *Izy Boukir*, dissolves three dimensions into two and back again — an idea Graves continuously explored by working in various media.

Graves' first use of color had been dictated by the subjects of her sculpture. In the bathymetric and topographic map paintings, color was specified information and it related to the subject matter. In the lunar pictures, Graves pursued the problem of non-relational color. In the works of 1975-76, she had abstracted forms from their subjects and had thereby eliminated any real meaning in relating color to image. By 1977 the colors and the images were completely independent from their sources and had their own integrity.

The paintings from 1977 to the present have not been made in series. They stand as single statements, each of which differs from the others. Graves now has a lexicon of colors and forms which she can integrate towards a more purely painterly end. It is apparent that her paintings now interface themselves technically and in terms of image with all the previous work. Technique and process exclusively determine the transformation of information. While Graves certainly made aesthetic and visual choices in all of her previous work, the work until now was based on, or honored, information or systems of research and investigation. The decisions Graves made in her work were primarily ones of selection. She selected colors and forms from memory. The paintings she made were no longer about anything other than themselves.

*Defacta*, 1977 (Cat. no. 37) and *Zitla*, 1977 (Cat. no. 42) are

both energetic, dense paintings, typified by overall marking. In them Graves was working with a holistic but abstract composition. She was no longer transferring shapes onto the canvas in a predetermined or sequential manner. The shapes were added one on top of another. The space was layered by the colors and the opacity or translucency that occurs in their application. The colors defined shapes which, in their turn, sometimes recalled, very generally, cloud formations or topography.

At this time, Graves also began work on large watercolors, of which *Zil (Moonwater Series)*, 1977 (Cat. no. 41), *Angius*, 1978 (Cat. no. 43) and *Crisium*, 1978 (Cat. no. 47) are examples. She worked on wet sheets of paper and completed the drawings rapidly, at one sitting. This precluded the possibility of drawing a form and filling it in as she had done in previous works. Each gesture or stroke of paint became form. The colors bled into one another, their edges merging. The composition of these watercolors and of the 1978 paintings was typified by linear elements which pushed out from the center towards, but not quite reaching, the edges of the rectangle.

Since 1978, Graves' paintings have contained more references to the vocabulary of forms which she had developed over the previous ten years. In *Pkoeth*, 1978 (Cat. no. 55) and *Areol*, 1978, there are discernible shapes related to weather and bathymetric maps but the forms now transcend the single function of representation. They have a dual role wherein there is the capacity for choice of interpretation. The forms one may recognize as camel legs in *Lam*, 1978 (Cat. no. 52) or *Disclose*, 1978, are pictorial representations of those forms, rather than a two-dimensional equivalent of their experience as sculpture. The abstraction, by color and placement of, for example, a camel or totem image, deletes an emotional element which could possibly obscure it as painted form. Graves has reached into her own work to reassess and reassemble its language. She now has the vocabulary to accomplish something that is related to her early work but is at the same time different.

---

10   Nancy Graves, *The Artist Presents Her Films* (Buffalo: Albright-Knox Art Gallery, April 3, 1974), film notes.

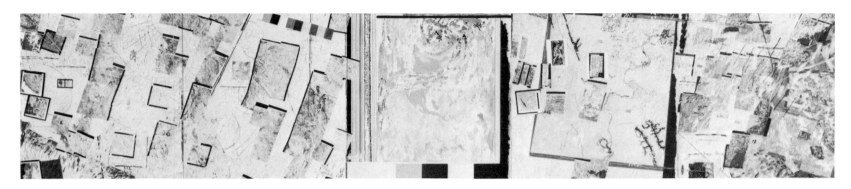

Fig. no. 11
**Painting U.S.A.,** 1975
acrylic, oil and gold leaf on canvas, 65 x 320"
(five panels 65 x 64" each)
Collection Museum des 20. Jahrhunderts, Vienna

In the two most recent examples of her work, *Calibrate*, 1979 (Cat. no. 61) and *Calipers, Legs, Lines*, 1979 (Cat. no. 62) as is suggested in the titles, one can find shapes and patterns from her sculpture. She no longer extracts her material exactly from its sources. The sources are reminders, seen through the other work, for ideas about composition, shape, color and scale. The work is perceived first as a painting or a sculpture (not as a camel, a bone or a map). As in her previous work, the size and scale remain important so that parts may be seen either separately from the whole or so that the whole may be viewed without detail at a greater distance. Layering as a method of affecting viewing time and space has been a constant concern in Graves' work. The repetition of images each separately conceived and rendered is continued in the new work. The artist now uses abstract compositional devices to achieve a gestalt instead of allowing it to be dictated by the information itself.

Graves is currently working on several canvases at one time. She moves from one to another as each evolves towards its conclusion. At the same time she is making sculpture, which is delivered from the foundry to the studio so she can see it alongside the paintings. She returned to making sculpture in 1976, when she was commissioned by the Ludwig Museum in Cologne, West Germany, to create a permanent fossil piece. Selecting prototype parts for molds from the sculpture *Fossils*, 1970, she transferred the waxes into unique forms. She worked at the Tallix Foundry in New York to cast an original work on the same theme in bronze. At the foundry, Graves learned the lost wax process — a technique which allowed her to "draw" with wax and to color the bronzes by painting with chemicals and fire. The early sculpture, made of wax and other fragile materials, was used as a point of departure — not replication. *Graph*, 1970, which originally hung from wall to floor, became *Evolutionary Graph II*, 1978 (Cat. no. 49), a floor piece fabricated of bronze sheets which were cut, bent, welded and patined. *Seven Legs*, 1978 (Cat. no. 57) and *Column*, 1979 (Cat. no. 63), combine casting and fabrication and were derived from *Variability and Repetition of Variable Forms*, 1971.

Following this, she began a group of works made from a set of drawings which she had done in the library of the American Academy in Rome in the spring of 1977. These drawings were of archaeological sites and they depicted

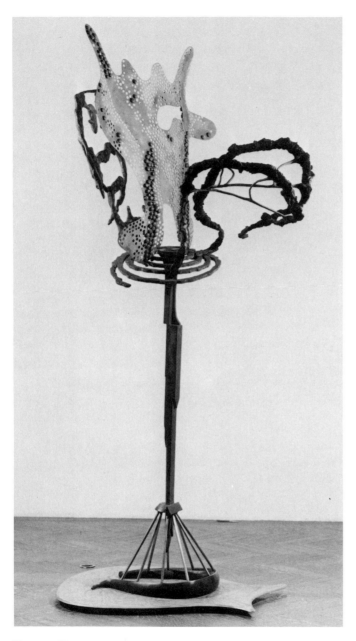

Fig. no. 12
**Bathymet — Topograph,** 1978-79
polychrome bronze, 82 x 36 x 30"
Collection Museum des 20. Jahrhunderts, Vienna

geography, maps, charts and artifacts. The necessity of transferring the two-dimensional drawings into three-dimensional forms presented her with structural problems she had not encountered in her earlier sculpture. The drawings provided the inspiration for elements or parts which Graves had to join together physically. The principal problem was, in Graves' words, "the question of the third dimension and how to realize it without having seen it."[11] The sculpture demonstrates how she constantly moves vertical information to horizontal and back again.

*Bathymet — Topograph,* 1978-79 (Fig. no. 12) as the title implies, is a combination of bathymetric and topographic mapping devices which informed Graves' 1971-73 paintings. The piece evolved out of a number of drawings whose parts Graves could not translate physically until she had investigated the process which could transform it into sculpture.

*Archaeologue,* 1979 (Fig. no. 13) is a sculpture utilizing three separate archaeological sources with content ranging from the general to the specific; first, a site plan of a pre-historic dwelling, second, a cave wall with a drawing on it and third, a fragmented vase found on the site which introduces into the work the concept of container and contained, reminiscent of the 1970-71 sculpture. She has abstracted the information, changing the scale relationships between the parts. The colors change to emphasize the changes in scale.

*Archaeoloci,* 1979 (Cat. no. 59) is based on studies of a Mediterranean archaeological site. Blue curvilinear forms depict the sea and the step-like forms, which act as the support, are renderings of the breakwater found at the site. The base is a topographical rendering of another dwelling site. Technically,
". . . *the base is a fabrication of sheets of wax which were punched out, shaped, bent, fused . . . . I brought a prototype in wax to the foundry which was close to the image made to scale in my drawings . . . there are two things going on as [I] continued*

11  Richard Polich, interview with Nancy Graves (New York, February 24, 1980), unpublished.

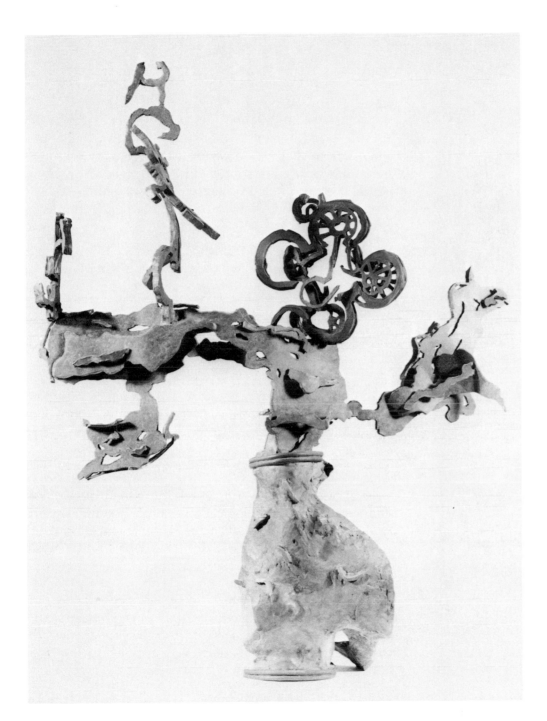

Fig. no. 13
**Archaeologue,** 1979
polychrome bronze and oil, 32 x 25½ x 11"
Private collection, courtesy William Zierler, Inc.,
New York

*to work on the new pieces. The choices of materials and surfaces and processes of forms expand and at the same time the end image is less clear at the outset. As I increase the complexity of sculptural parts, the solution becomes more open.*"[12]
She can now reassert her images — bones, camels, totems, ocean floors, clouds, archaeological sites and evidence in various ways. The technique is now the catalyst.

In her recent sculpture, Graves attempts to "translate the form in as many ways possible into a sculptural solution."[13] To do this she has become deeply involved in technique. She uses the play of considered information and the physical necessity of transforming it into sculpture to evolve the final forms. She connects inspiration to technique. By using forms known to her she has been able to experiment freely with color and surface and achieve monumental sculpture. Graves, with the assistance of technicians, is involved throughout the making process; she herself renders each gesture solid. Her work has always been on a life-sized or human scale and while she is now shifting scale in her sculpture, the sizes remain the same. For all her previous sculpture there had been an existing form from which to begin. The new sculpture is generated when she finds shapes which are of interest as sculptural problems.

In the new work, disparate elements, forms and objects are joined together. She has abandoned thematic treatment of the subjects. Graves now has freedom to juxtapose. Line can represent or enclose. Pattern can signify something or merely unify or disperse a color. A shift in plane can change vision or indicate information to be read or defined specifically. Forms can be lazy or energetic, vertical or horizontal, beneath or above, realistically rendered or colored and related or not.

Graves has not followed the tendency of so many artists of this decade. She has not developed from abstraction a method of working for which only intellectual material was possible. Her sculpture parallels her painting and each

12   Ibid.
13   Ibid.

influences the other beyond the physical limitations. As she continues both painting and sculpting, the two interact in a sophisticated and immediate way. She has extracted an identity from painting and from sculpture which she pushes towards a combination of the strengths she has found in each.

Her recent methods of composing paintings can now be used as possibilities for arranging the forms in sculpture. Additive sculpture, like the paintings, has no "reason" for beginning or ending. The reason to start is inspired by an instinctive response to a subject, shape, color, quality of density or line. The work is finished when it becomes complete reality.

The use of unfamiliar materials and images in her first sculpture placed Graves' work in a context for which we were unprepared. Her acceptance of ancient as well as highly advanced systems of information increased our difficulty in seeing her art except through its most simplistic interpretation. Rather than merely documenting, she has studied and reconstructed visual information of various sorts. By choosing what is culturally significant, Graves has assumed for her work a place in history.

Graves' relationship to her peers has been a difficult one. Working with many similar formal concerns, her choice of subject matter has placed her outside the practice of abstraction predominant in the last decade. She has expressed the view that, at certain times, ideas may become concurrently viable in many creative areas. These ideas are seized upon by the most curious and adventurous of minds. Her link to her contemporaries is a connection of ideas rather than forms. Since there are many ways to solve a problem, the rightness of one solution over another is a matter for history.

To create, out of re-creating, in order to allow a way of seeing what exists that is culturally significant is at the heart of this artist's work. Where it goes from here will be dictated by where the mind goes. □

## Catalogue of the Exhibition

All dimensions are given in inches, height preceding width and depth.

1
**Camel VI,** 1969*
wood, steel, burlap, polyurethane,
skin, wax and oil
96 x 126 x 48
Collection National Gallery of Canada, Ottawa

2
**Head on Spear,** 1969
steel, wax, marble dust, acrylic,
animal skin and oil
96 x 24 x 12
Janie C. Lee Gallery

3
**Fossils,** 1970
wax, gauze, marble dust, acrylic and steel
36 x 300 x 300
Collection of the artist

4
**Signs Exchanged Between Ireteba, Sub-Chief of the
Mojave, and Major Beale, Aboard the "General Jessup,"
While Ferrying 16 Camels (Property of the U.S.
Government) Across the Colorado River Near Needles,
California, January 1858,** 1970
ink on paper
17 x 14
Collection Carol Lindsley

5
**Variability of Similar Forms,** 1970
steel, wax, marble dust and acrylic
84 x 216 x 180
Collection of the artist

6
**Camouflage Series #5,** 1971-74
acrylic and oil on canvas
90 x 72
Collection Albright-Knox Art Gallery, Buffalo, New York
James S. Ely Fund, 1977

7
**Interaction Between Bullhead Strangers,** 1971
gouache on paper
30 x 20
Collection David and Marilyn Reichert

8
**Lady Bug Beetle Swarm/Wintering in California,** 1971
gouache on paper
22½ x 30
Collection Dr. and Mrs. Edward Okun

9
**Low Relief and Engraved Frieze of Women
& Bison from Angles sur l'Anglin,** 1971
gouache on paper
30 x 22½
Collection of the artist

10
**Nefertiti — Wiring of a Starfish,** 1971
gouache and India ink on paper
30 x 22½
Collection of the artist

11
**Paleolithic Carved Objects,** 1971
gouache on paper
30 x 20
Collection Mr. and Mrs. Robert Kardon

12
**Palimpsest of Fairy Rock,** 1971
gouache, acrylic and India ink on paper
30 x 22½
Collection of the artist

13
**Photographs of Jumping Frog at 1/40 Second,** 1971
gouache on paper
29 x 20
Collection of the artist

14
**Antarctica,** 1972
acrylic and ink on canvas
96 x 72
Collection University of Texas at Dallas
Gift of Mrs. Eugene McDermott

15
**Geological Survey — Egton, England,** 1972
gouache on paper
22 x 29½
Collection of the artist

16
**Indian Ocean Floor I,** 1972
acrylic on canvas
90 x 72
Collection First City National Bank,
Houston, Texas

17
**Molucca Seas,** 1972
acrylic and ink on canvas
102 x 72
Collection Janie C. Lee

18
**Montes Apenninus Region of the Moon,** 1972
acrylic on canvas
72 x 96
Collection Des Moines Art Center, gift of
Jay H. and Beverly B. Perry Foundation, Inc.,
Scarsdale, New York in memory of
Mr. A. H. Blank, 1973

19
**Nearside of the Moon 20°N-S x 70° E-W,** 1972
acrylic on canvas
96 x 288 (4 panels 96 x 72 each)
Anonymous gift, The Museum of Fine Arts,
Houston, Texas

20
**Part of Sabine D. Region of the Moon,**
**Southwest Mare Tranquilitatis,** 1972
acrylic on canvas
72 x 96
Collection La Jolla Museum of Contemporary Art,
purchased with the aid of funds from the
National Endowment for the Arts

21
**Earth, Moon, Mars,** 1973
India ink, acrylic, gouache and graphite on paper
29¾ x 42
Collection of the artist

22
**Falkland Current,** 1973
graphite on paper
22½ x 30
Collection of the artist

23
**Mars, South Pole,** 1973
graphite, acrylic, gouache and India ink on paper
29¾ x 42
Collection of the artist

24
**Grand Canyon of Mars — 5000 kilometers**
**along the Martian Equator,** 1973
pencil, gouache and ink on paper
22½ x 30
Collection Albright-Knox Art Gallery, Buffalo, New York
Gift of The Binney Foundation, 1974

25
**Hurricane Camille,** 1973
India ink and acrylic on paper
22½ x 30½
Collection Janie C. Lee

26
**Map of Mars After Schiaparelli,** 1973
gouache on paper
22½ x 30
Collection of the artist

27
**Mars: Image & Noise, Noise, Corrected Image,** 1973
gouache, acrylic and India ink on paper
30½ x 67½ (3 panels 30½ x 22½ each)
Collection of the artist

28
**Starchart II,** 1973
gouache, pencil, acrylic
and India ink on paper
30 x 22½
Private collection

29
**Untitled #1, Green,** 1973
acrylic on canvas
82 x 142
Collection Dallas Museum of Fine Arts
Gift of Mr. and Mrs. John D. Murchison

30
**Untitled (White),** 1974
watercolor, oil, graphite and acrylic on paper
22½ x 60 (2 panels 22½ x 30 each)
Collection of the artist

31
**Untitled #6, White,** 1974
acrylic and oil on canvas
87 x 130
Collection of the artist

32
**Rheo,** 1975
acrylic, oil and gold leaf on masonite
64 x 64
Collection Wilhelmina and Wallace Holladay

33
**Bish,** 1976
pastel on paper
38 x 50
Private collection

34
**Duir L. O. Series,** 1976
oil on canvas
64 x 88
Collection Lisa Negley Dorn

35
**Yot K. Series,** 1976
pastel on paper
38 x 50
Collection Mr. and Mrs. Ezra P. Mager

36
**Kadsura L. O. Series,** 1976
oil on canvas
64 x 88
Collection of the artist

37
**Defacta,** 1977*
oil on canvas
64 x 76
Collection Mr. and Mrs. Larry Horner, Los Angeles

38
**Quasi-Quasi,** 1977
oil on canvas
90 x 60 (2 panels 90 x 30 each)
Collection Mr. and Mrs. Fulton Murray, Dallas, Texas

39
**Trace,** 1977*
oil and acrylic on canvas
64 x 64
Private collection

40
**Weke,** 1977
watercolor on paper
44 x 65¾
Collection Albright-Knox Art Gallery, Buffalo, New York
Gift of Seymour H. Knox, 1978

41
**Zil (Moonwater Series),** 1977
watercolor on paper
44½ x 55⅝
Collection Mr. and Mrs. Laurence Kramer

42
**Zitla,** 1977
oil and encaustic on canvas
71 x 53
Collection Mr. and Mrs. Jay I. Bennett

43
**Angius,** 1978
watercolor on paper
73¼ x 44
Private collection, courtesy William Zierler, Inc.,
New York

44
**Approaches the Limit of,** 1978
oil and encaustic on canvas
84 x 64
Collection of the artist

45
**Aurignac,** 1978
polychrome bronze
43 x 20 x 27
Collection Mr. and Mrs. H. Christopher J. Brumder

46
**Cert,** 1978
oil on canvas
73 x 52
Collection Sawnie Ferguson

47
**Crisium,** 1978
watercolor on paper
63⅝ x 44
Private collection

48
**Equivalent,** 1978
oil and encaustic on canvas
64 x 100
Collection of the artist

49
**Evolutionary Graph II,** 1978*
polychrome bronze
51 x 54 x 67
Collection Skinner Corporation

50
**Folium,** 1978
oil and encaustic on canvas
60 x 90
Collection Brooks Memorial Art Gallery
Memphis, Tennessee
Gift of Art Today

51
**Grafeit,** 1978
acrylic, oil and encaustic on canvas
64 x 88
Collection of the artist

52
**Lam,** 1978
oil and encaustic on canvas
50 x 114 (3 panels 50 x 38 each)
Private collection

53
**Nubium,** 1978
watercolor on paper
62⅝ x 44
Collection Mary S. Myers

54
**Quipu,** 1978
polychrome bronze
70 x 60 x 58
Helen Elizabeth Hill Trust, Houston, Texas

55
**Pkoeth,** 1978**
oil on canvas
60 x 90
Collection Dr. and Mrs. Charles Schneider

56
**Screen,** 1978
oil on canvas
64 x 84
Collection Mr. and Mrs. Norman Braman

57
**Seven Legs,** 1978
polychrome bronze
69½ x 16 x 22
Courtesy M. Knoedler & Co., Inc., New York

58
**Shadow/Reflection,** 1978*
polychrome bronze
57¾ x 52 x 34
Collection Joel and Paula Friedland

59
**Archaeoloci,** 1979
polychrome bronze and oil
39½ x 30 x 27
Courtesy M. Knoedler & Co., Inc., New York

60
**Aves,** 1979
polychrome bronze
46½ x 82 x 30
Collection of the artist

61
**Calibrate,** 1979
acrylic and oil on canvas
64 x 72
Collection Mr. and Mrs. Mark Lederman,
New York

62
**Calipers, Legs, Lines,** 1979 (cover illustration)
acrylic and oil on canvas
64 x 88
Private collection, courtesy William Zierler, Inc.,
New York

63
**Column,** 1979
bronze
72½ (base: 4 x 6½ x 14)
Courtesy M. Knoedler & Co., Inc., New York

64
**Trace,** 1980
polychrome bronze, steel and oil
107 x 115 x 50
Collection Mr. Graham Gund, Boston

*This work will not travel to Memphis, Purchase, Des Moines and Minneapolis.
**This work will be shown only in Buffalo.

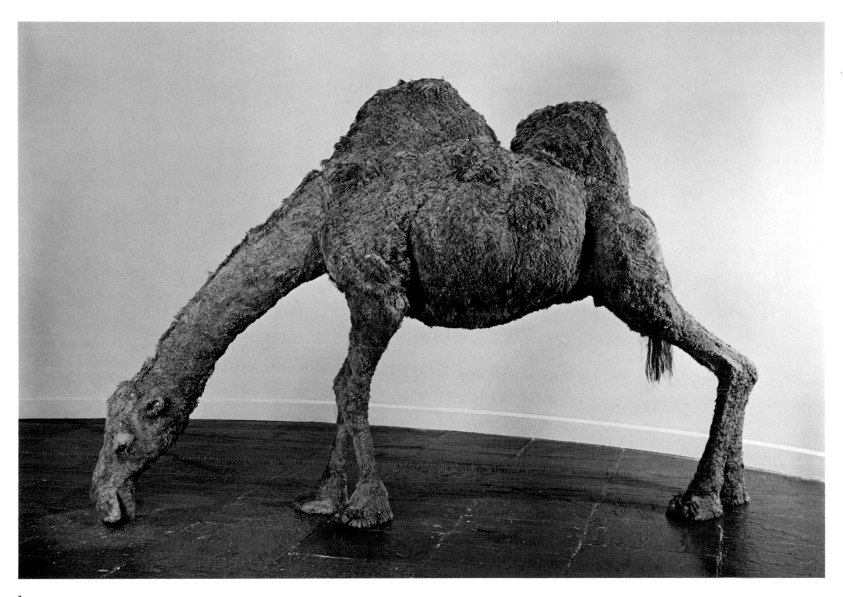

1
**Camel VI,** 1969
wood, steel, burlap, polyurethane,
skin, wax and oil
96 x 126 x 48
Collection National Gallery of Canada, Ottawa

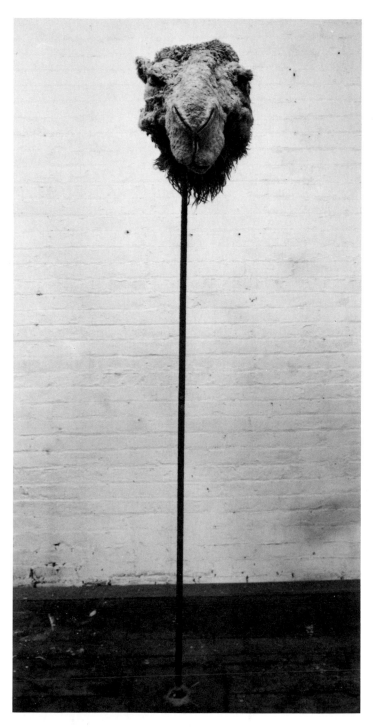

2
**Head on Spear,** 1969
steel, wax, marble dust, acrylic,
animal skin and oil
96 x 24 x 12
Janie C. Lee Gallery

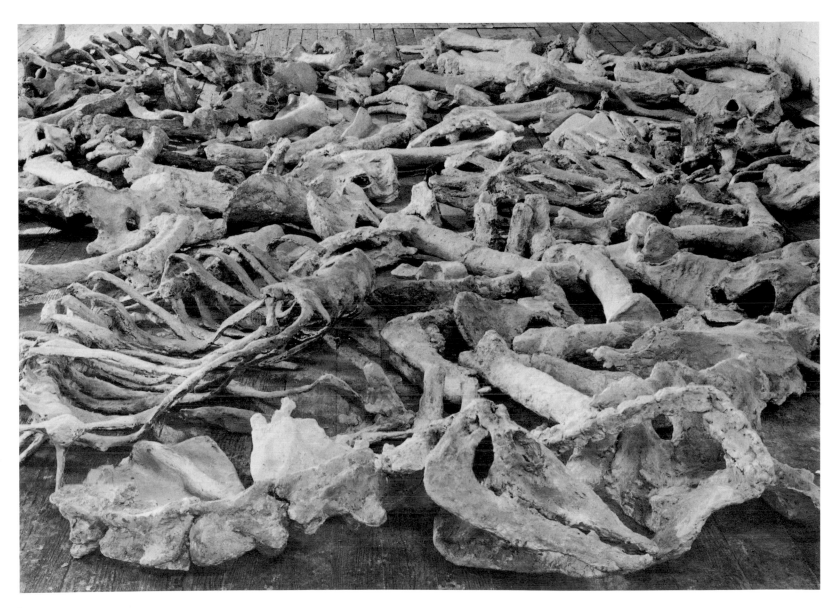

3
**Fossils,** 1970
wax, gauze, marble dust, acrylic and steel
36 x 300 x 300
Collection of the artist

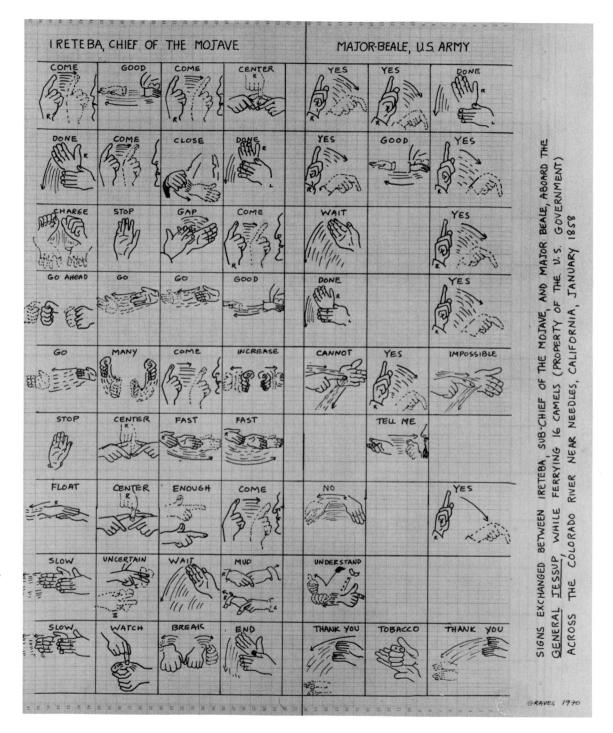

4
**Signs Exchanged Between Ireteba,
Sub-Chief of the Mojave, and Major
Beale, Aboard the "General Jessup,"
While Ferrying 16 Camels (Property
of the U.S. Government) Across the
Colorado River Near Needles,
California, January 1858,** 1970
ink on paper
17 x 14
Collection Carol Lindsley

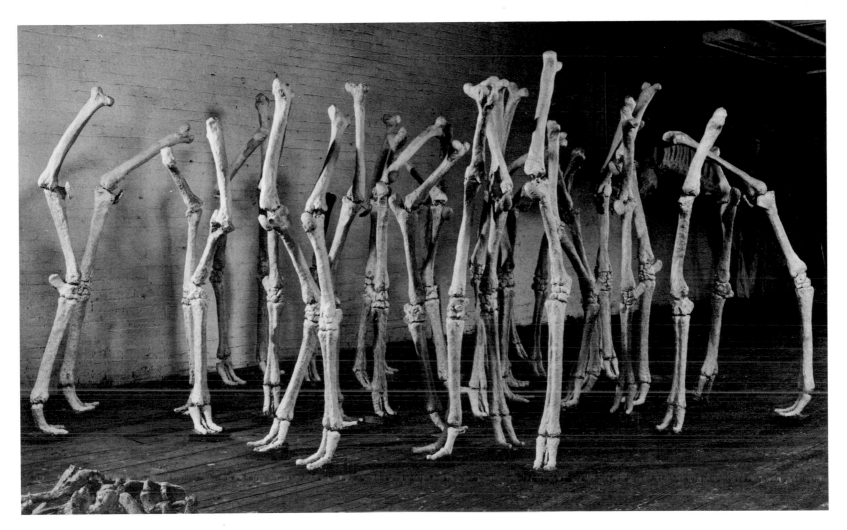

5
**Variability of Similar Forms,** 1970
steel, wax, marble dust and acrylic
84 x 216 x 180
Collection of the artist

6
**Camouflage Series #5,** 1971-74
acrylic and oil on canvas
90 x 72
Collection Albright-Knox Art Gallery,
Buffalo, New York
James S. Ely Fund, 1977

7
**Interaction Between Bullhead Strangers,** 1971
gouache on paper
30 x 20
Collection David and Marilyn Reichert

8
**Lady Bug Beetle Swarm/Wintering in
California,** 1971
gouache on paper
22½ x 30
Collection Dr. and Mrs. Edward Okun

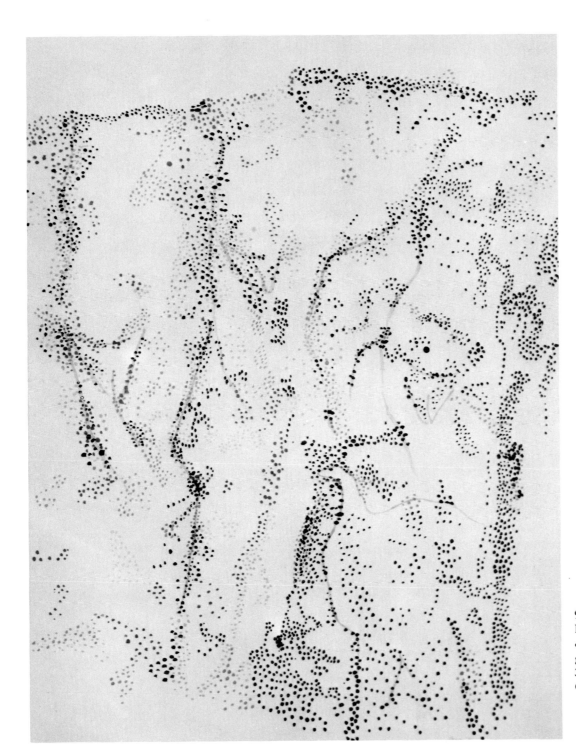

9
**Low Relief and Engraved Frieze of Women & Bison from Angles sur l'Anglin,** 1971
gouache on paper
30 x 22½
Collection of the artist

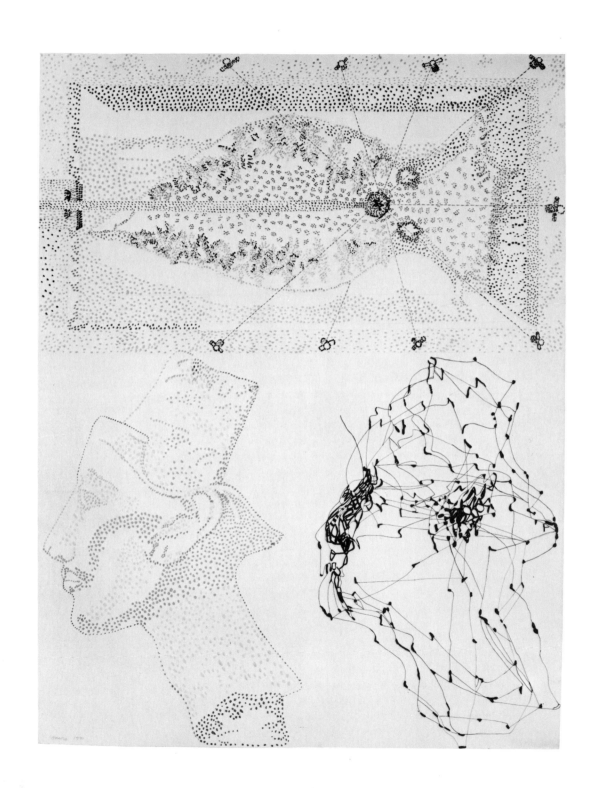

10
**Nefertiti — Wiring of a Starfish,** 1971
gouache and India ink on paper
30 x 22½
Collection of the artist

46

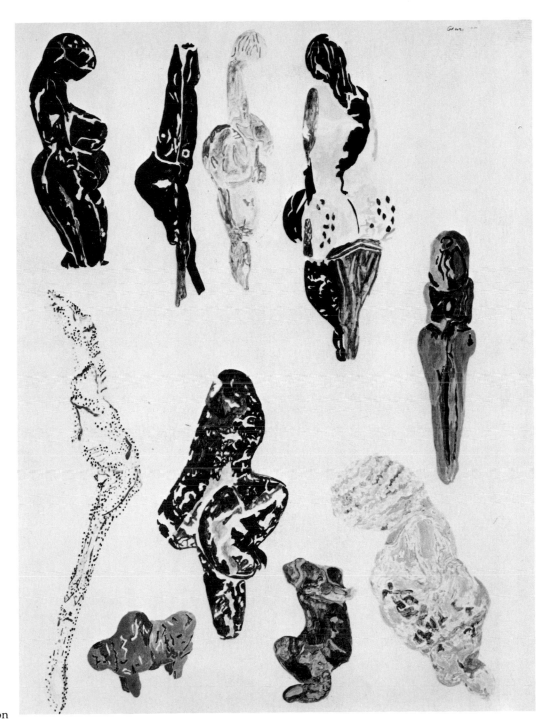

11
**Paleolithic Carved Objects,** 1971
gouache on paper
30 x 20
Collection Mr. and Mrs. Robert Kardon

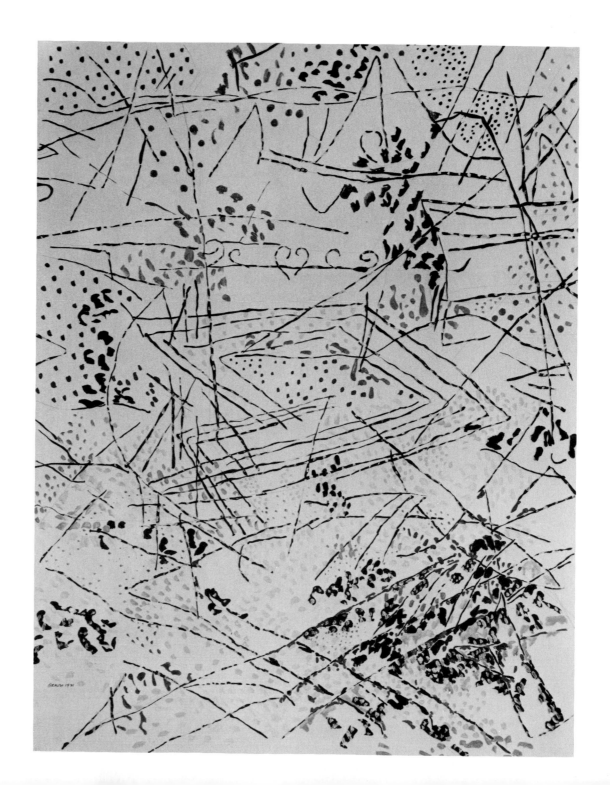

12
**Palimpsest of Fairy Rock,** 1971
gouache, acrylic and India ink on paper
30 x 22½
Collection of the artist

48

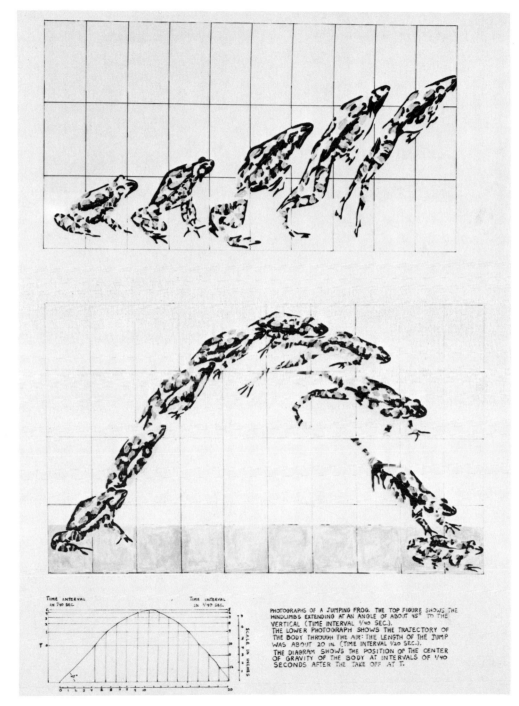

13
**Photographs of Jumping Frog at 1/40 Second,** 1971
gouache on paper
29 x 20
Collection of the artist

14
**Antarctica,** 1972
acrylic and ink on canvas
96 x 72
Collection University of Texas at Dallas
Gift of Mrs. Eugene McDermott

15
**Geological Survey — Egton, England,** 1972
gouache on paper
22 x 29½
Collection of the artist

16
**Indian Ocean Floor I,** 1972
acrylic on canvas
90 x 72
Collection First City National Bank,
Houston, Texas

17
**Molucca Seas,** 1972
acrylic and ink on canvas
102 x 72
Collection Janie C. Lee

18
**Montes Apenninus Region of the Moon,** 1972
acrylic on canvas
72 x 96
Collection Des Moines Art Center, gift of
Jay H. and Beverly B. Perry Foundation, Inc.
Scarsdale, New York in memory of
Mr. A. H. Blank, 1973

20
**Part of Sabine D. Region of the Moon,
Southwest Mare Tranquilitatis,** 1972
acrylic on canvas
72 x 96
Collection La Jolla Museum of Contemporary Art,
purchased with the aid of funds from the
National Endowment for the Arts

55

19
**Nearside of the Moon 20°N-S x 70°E-W,** 1972
acrylic on canvas
96 x 288 (4 panels 96 x 72 each)
Anonymous gift, The Museum of Fine Arts, Houston, Texas

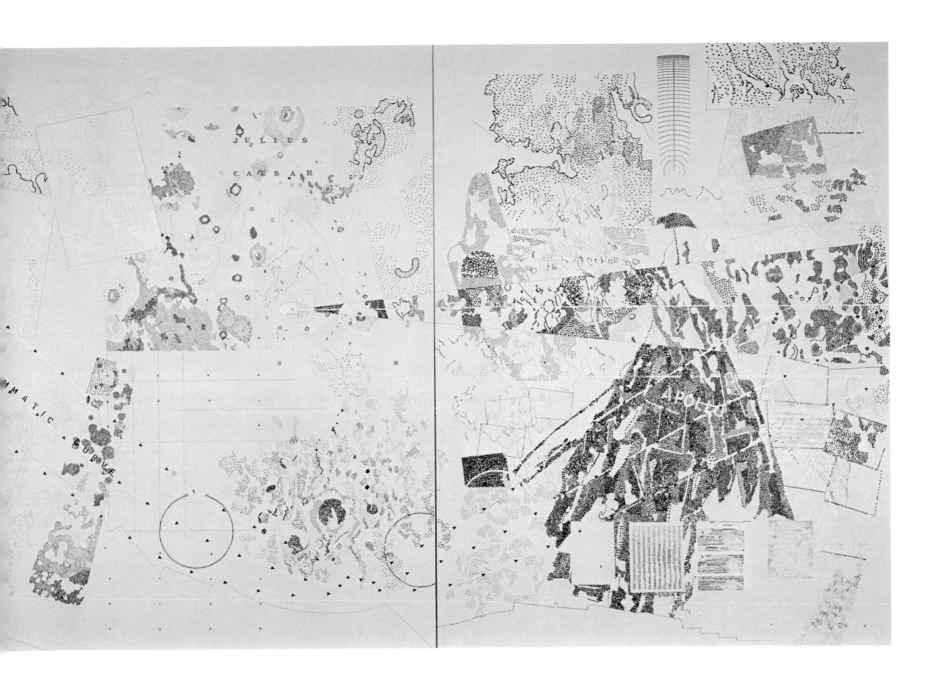

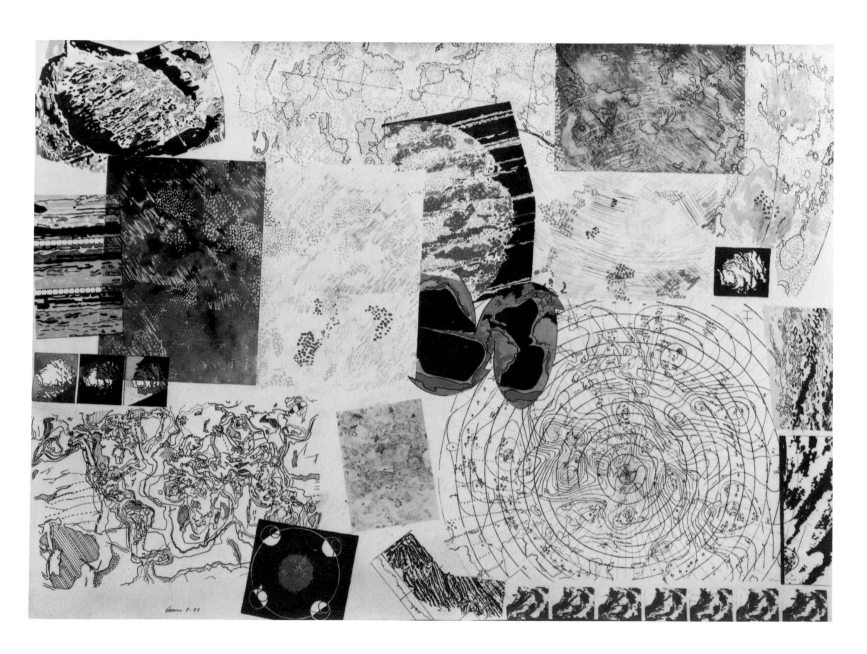

21
**Earth, Moon, Mars,** 1973
India ink, acrylic, gouache and graphite on paper
29¾ x 42
Collection of the artist

22
**Falkland Current,** 1973
graphite on paper
22½ x 30
Collection of the artist

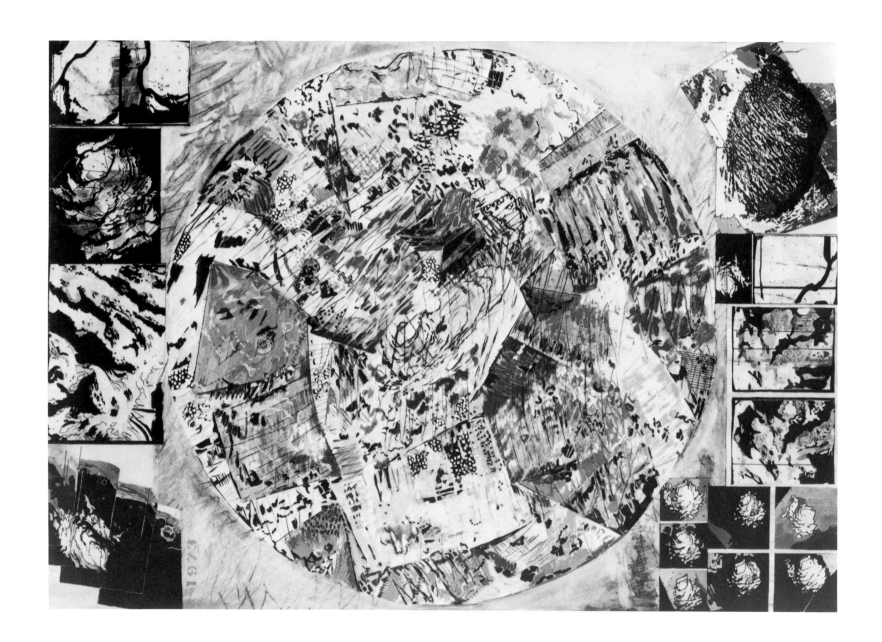

23
**Mars, South Pole,** 1973
graphite, acrylic, gouache and India ink on paper
29¾ x 42
Collection of the artist

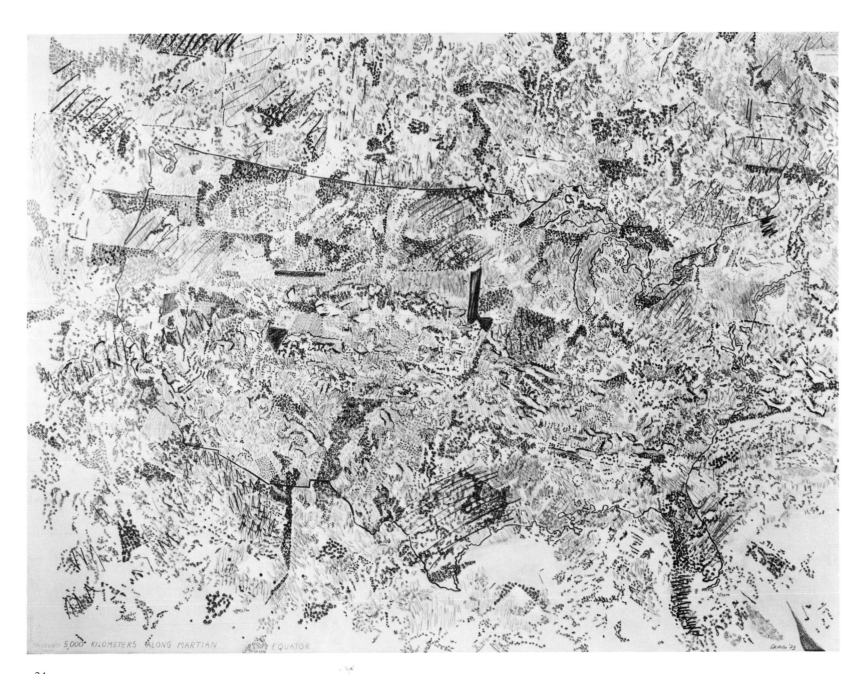

24
**Grand Canyon of Mars — 5000 kilometers
along the Martian Equator,** 1973
pencil, gouache and ink on paper
22½ x 30
Collection Albright-Knox Art Gallery, Buffalo, New York
Gift of The Binney Foundation, 1974

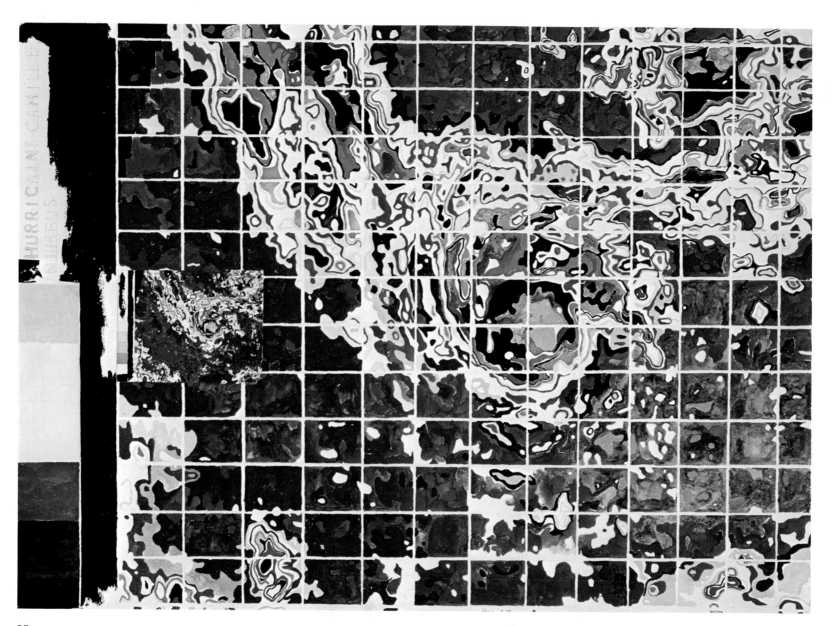

25
**Hurricane Camille,** 1973
India ink and acrylic on paper
22½ x 30½
Collection Janie C. Lee

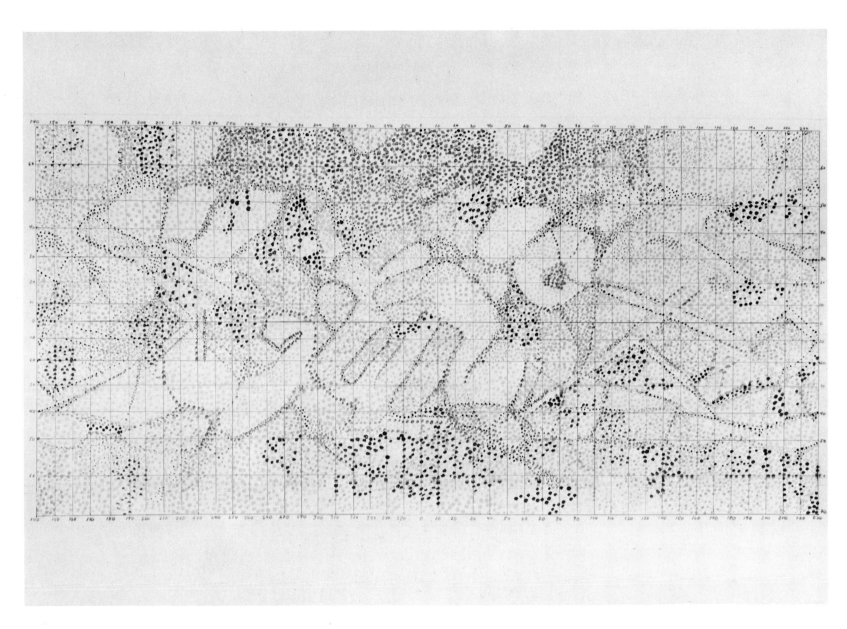

26
**Map of Mars After Schiaparelli,** 1973
gouache on paper
22½ x 30
Collection of the artist

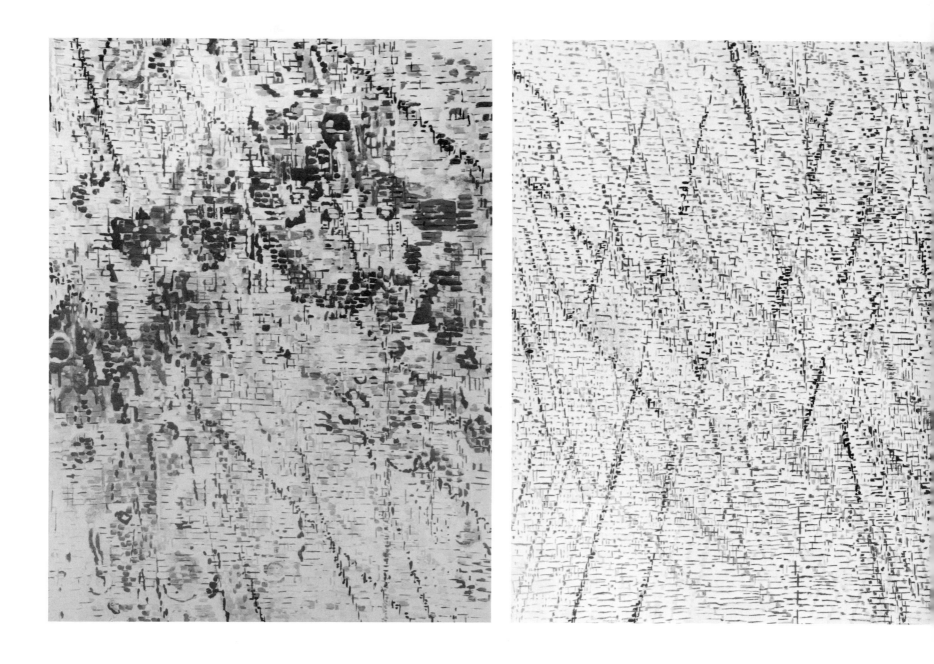

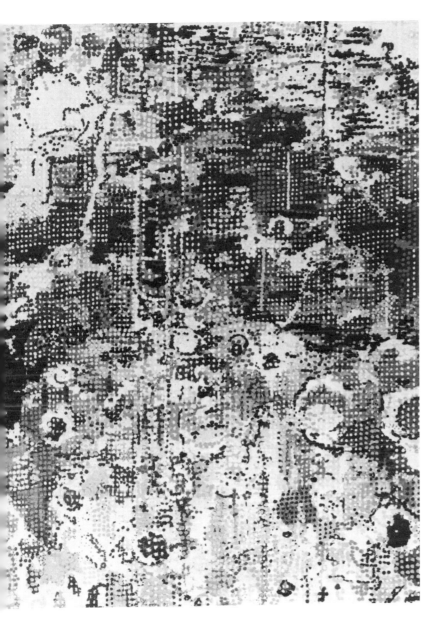

27
**Mars: Image & Noise, Noise, Corrected Image,** 1973
gouache, acrylic and India ink on paper
30½ x 67½ (3 panels 30½ x 22½ each)
Collection of the artist

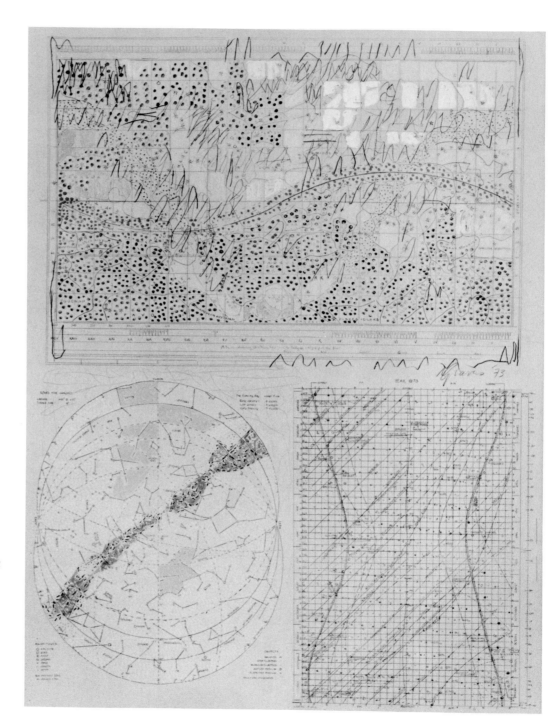

28
**Starchart II,** 1973
gouache, pencil, acrylic
and India ink on paper
30 x 22½
Private collection

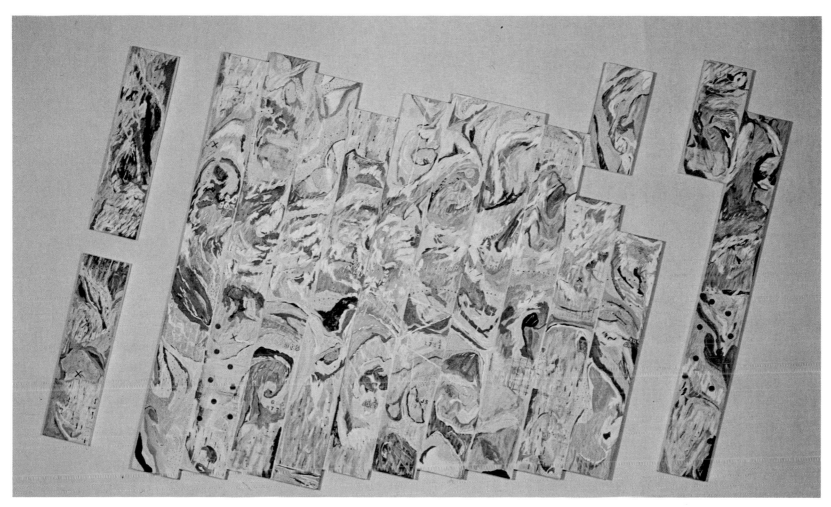

29
**Untitled #1, Green,** 1973
acrylic on canvas
82 x 142
Collection Dallas Museum of Fine Arts
Gift of Mr. and Mrs. John D. Murchison

30
**Untitled (White),** 1974
watercolor, oil, graphite and acrylic on paper
22½ x 60 (2 panels 22½ x 30 each)
Collection of the artist

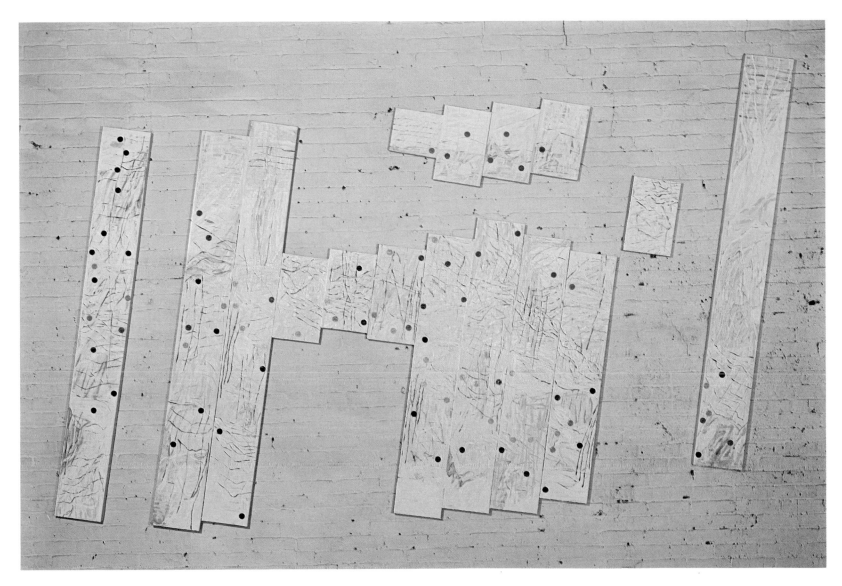

31
**Untitled #6, White,** 1974
acrylic and oil on canvas
87 x 130
Collection of the artist

32
**Rheo,** 1975
acrylic, oil and gold leaf on masonite
64 x 64
Collection Wilhelmina and Wallace Holladay

33
**Bish,** 1976
pastel on paper
38 x 50
Private collection

34
**Duir L. O. Series,** 1976
oil on canvas
64 x 88
Collection Lisa Negley Dorn

35
**Yot K. Series,** 1976
pastel on paper
38 x 50
Collection Mr. and Mrs. Ezra P. Mager

36
**Kadsura L. O. Series,** 1976
oil on canvas
64 x 88
Collection of the artist

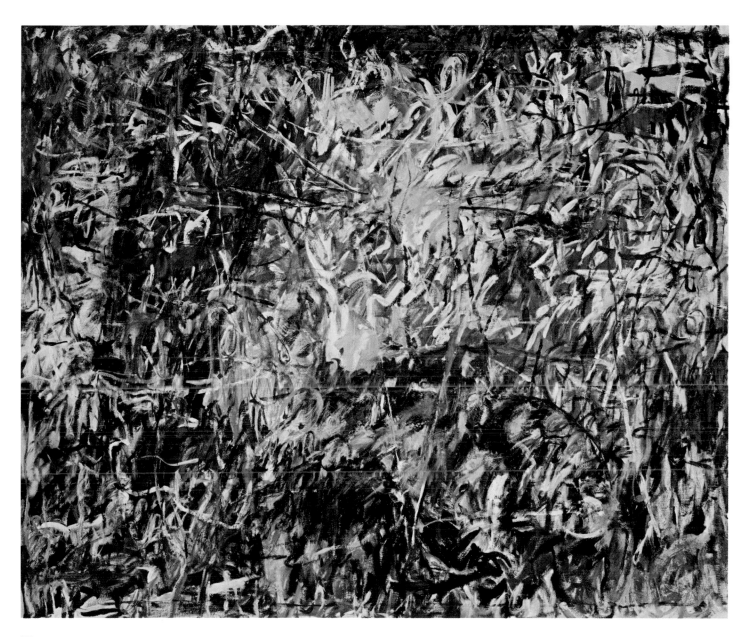

37
**Defacta,** 1977
oil on canvas
64 x 76
Collection Mr. and Mrs. Larry Horner, Los Angeles

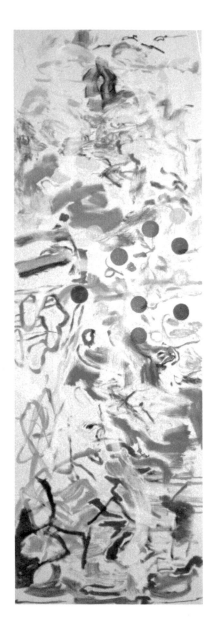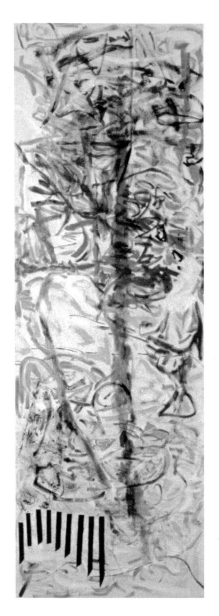

38
**Quasi-Quasi,** 1977
oil on canvas
90 x 60 (2 panels 90 x 30 each)
Collection Mr. and Mrs. Fulton Murray,
Dallas, Texas

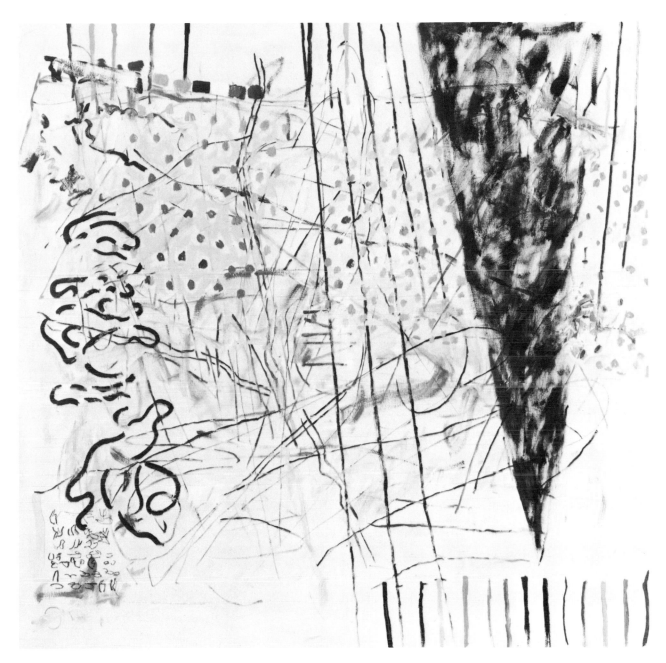

39
**Trace,** 1977
oil and acrylic on canvas
64 x 64
Private collection

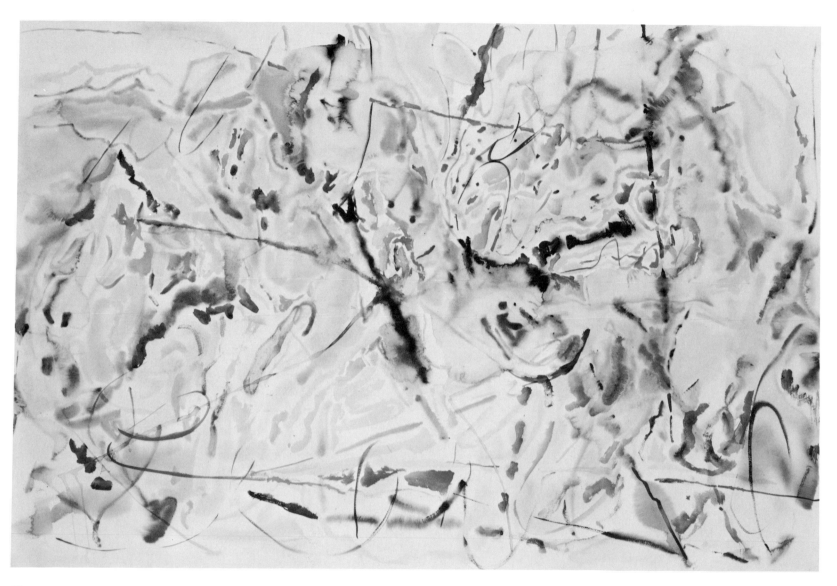

40
**Weke,** 1977
watercolor on paper
44 x 65¾
Collection Albright-Knox Art Gallery, Buffalo,
New York
Gift of Seymour H. Knox, 1978

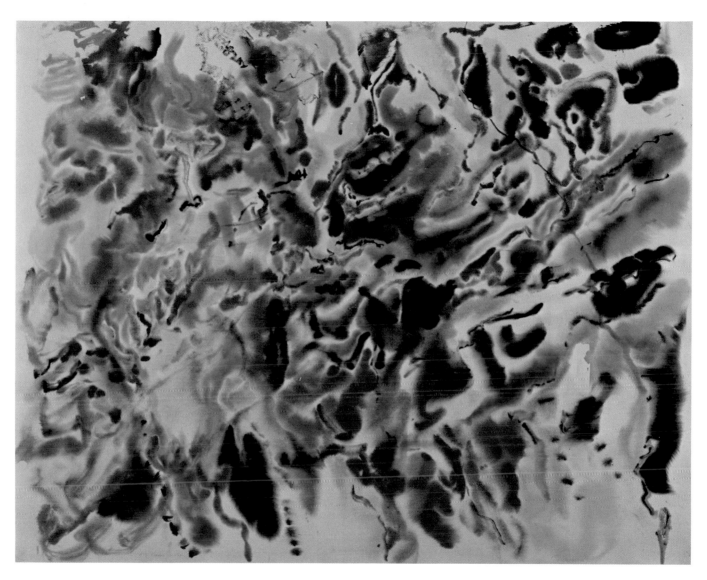

41
**Zil (Moonwater Series),** 1977
watercolor on paper
44½ x 55⅝
Collection Mr. and Mrs. Laurence Kramer

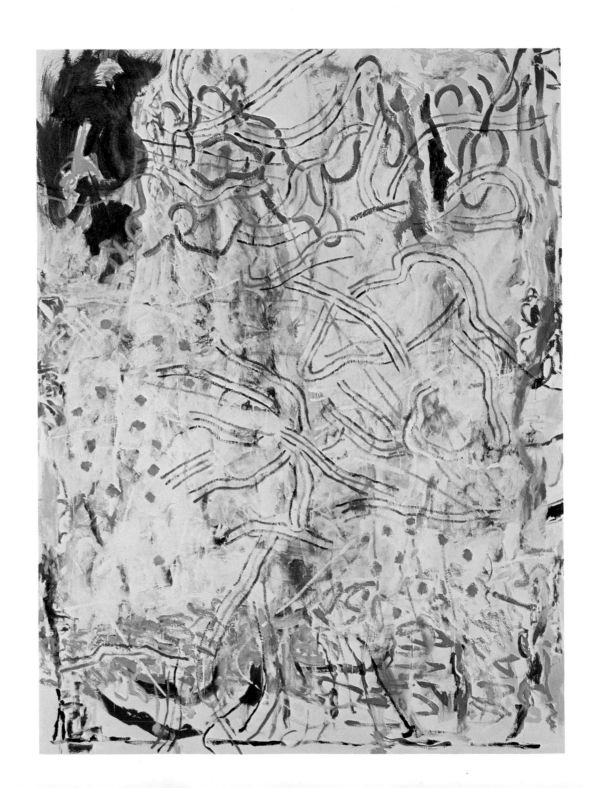

42
**Zitla,** 1977
oil and encaustic on canvas
71 x 53
Collection Mr. and Mrs. Jay I. Bennett

80

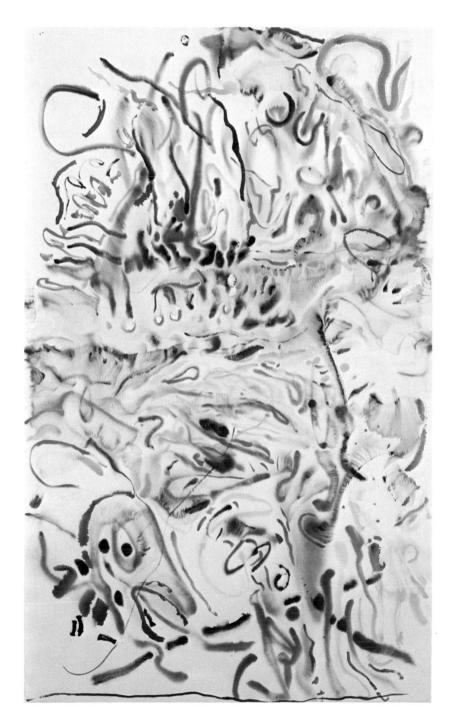

43
**Angius,** 1978
watercolor on paper
73¼ x 44
Private collection, courtesy William Zierler, Inc.,
New York

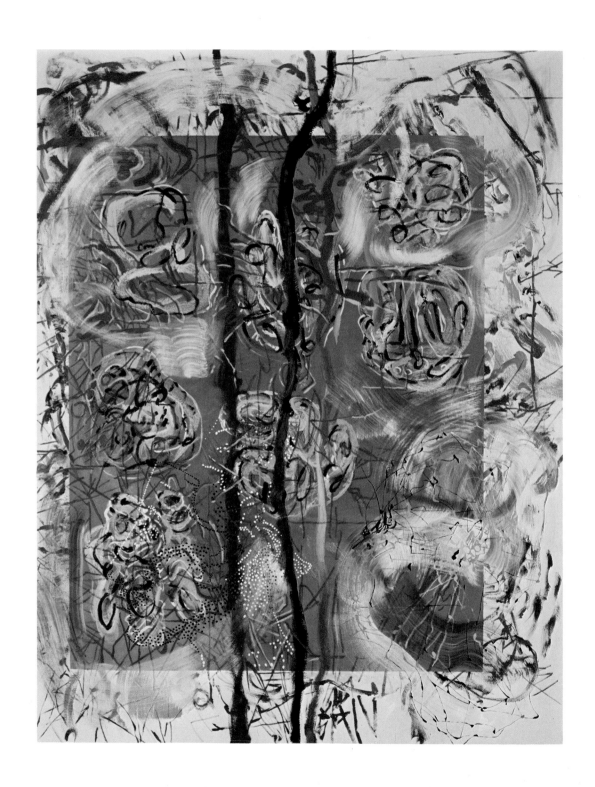

44
**Approaches the Limit of,** 1978
oil and encaustic on canvas
84 x 64
Collection of the artist

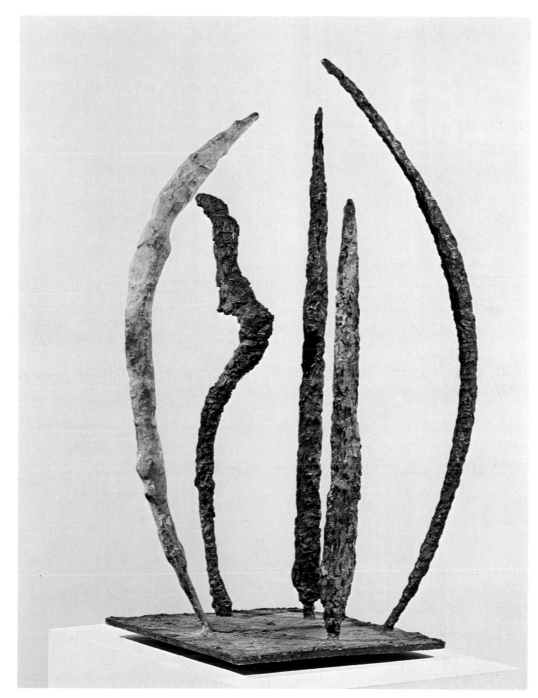

45
**Aurignac,** 1978
polychrome bronze
43 x 20 x 27
Collection Mr. and Mrs. H. Christopher J. Brumder.

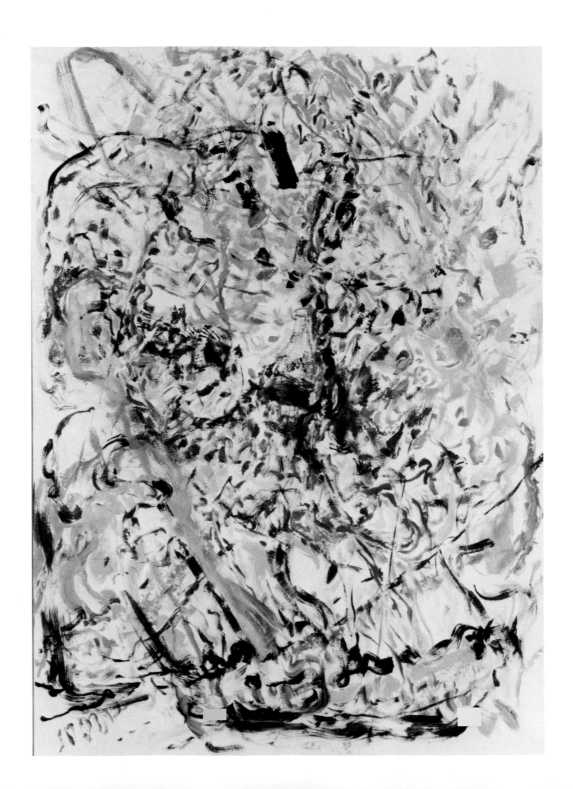

46
**Cert,** 1978
oil on canvas
73 x 52
Collection Sawnie Ferguson

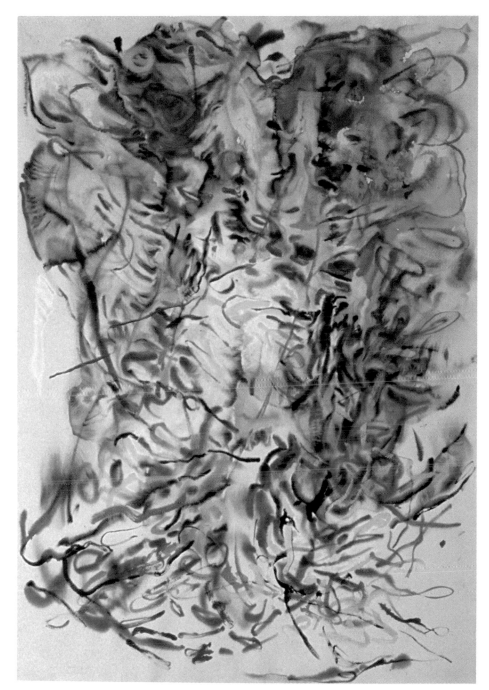

47
**Crisium,** 1978
watercolor on paper
63⅝ x 44
Private collection

48
**Equivalent,** 1978
oil and encaustic on canvas
64 x 100
Collection of the artist

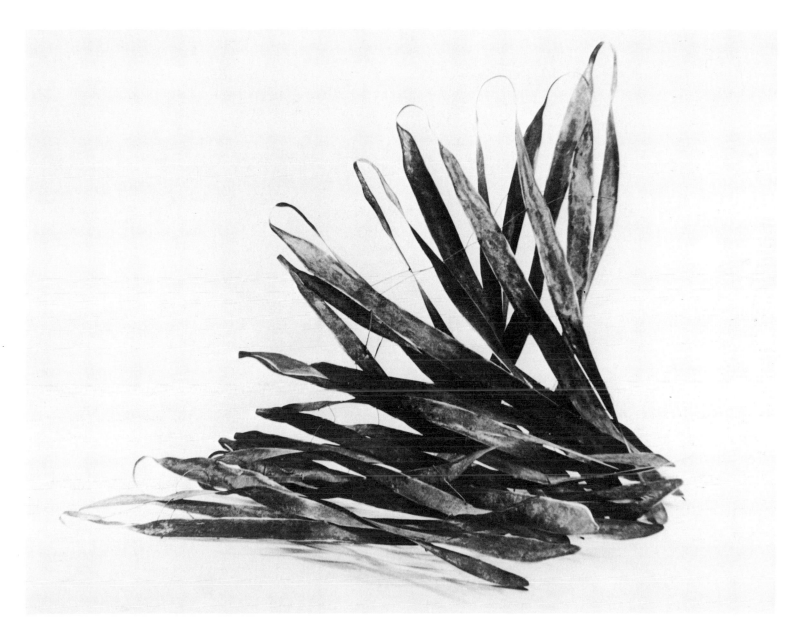

49
**Evolutionary Graph II,** 1978
polychrome bronze
51 x 54 x 67
Collection Skinner Corporation

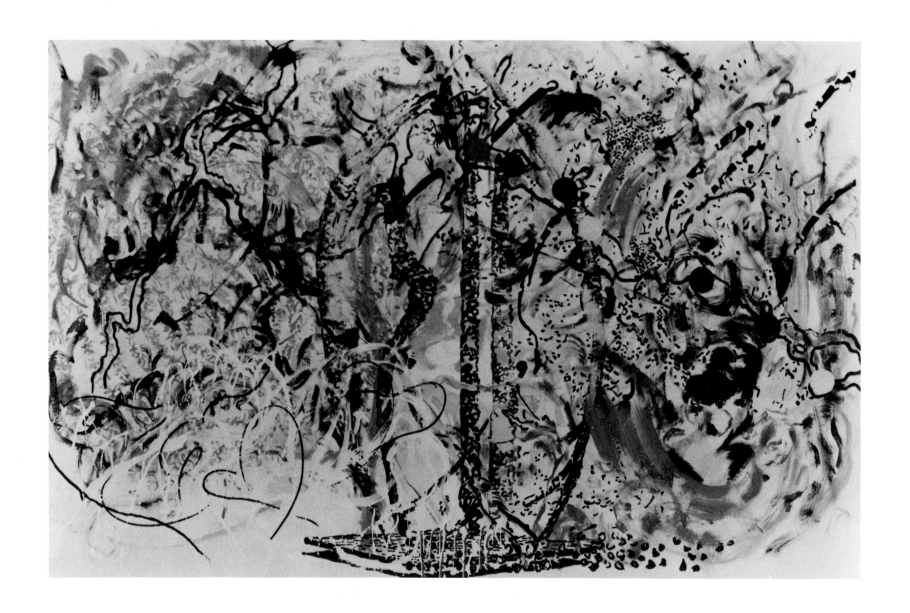

50
**Folium,** 1978
oil and encaustic on canvas
60 x 90
Collection Brooks Memorial Art Gallery
Memphis, Tennessee
Gift of Art Today

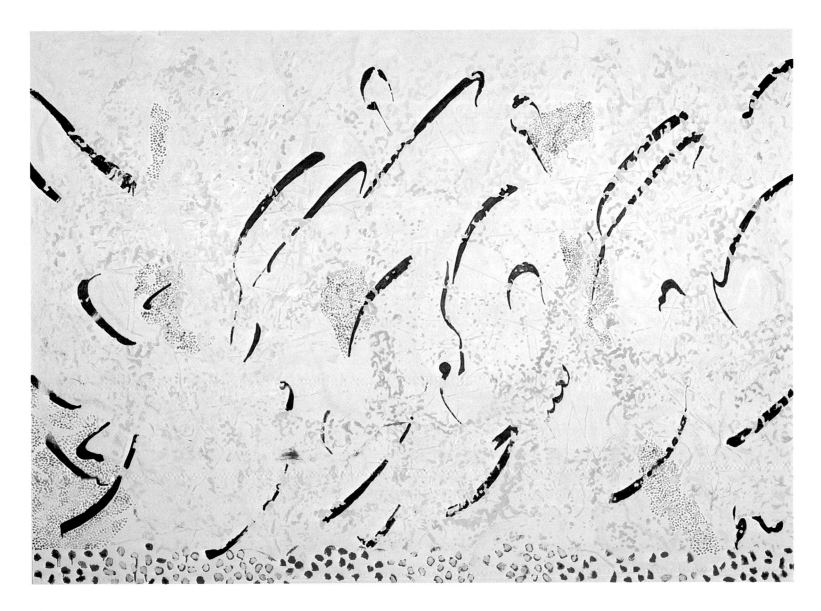

51
**Grafeit,** 1978
acrylic, oil and encaustic on canvas
64 x 88
Collection of the artist

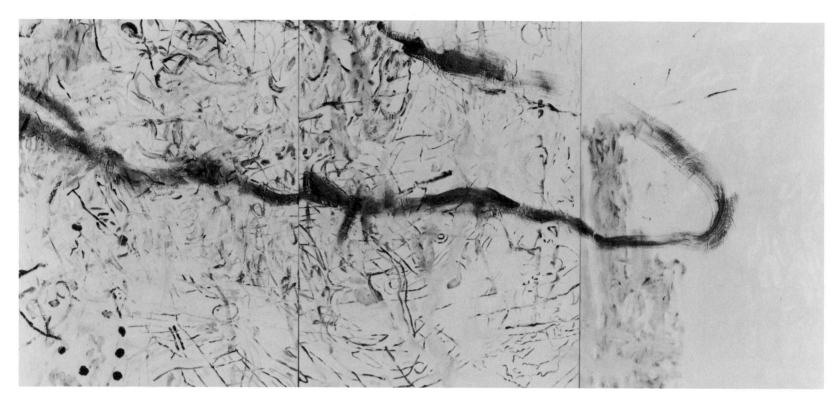

52
**Lam,** 1978
oil and encaustic on canvas
50 x 114 (3 panels 50 x 38 each)
Private collection

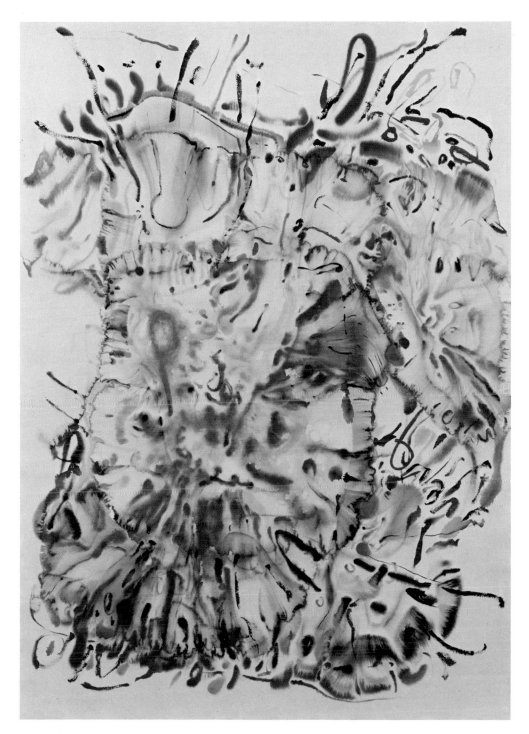

53
**Nubium,** 1978
watercolor on paper
62⅝ x 44
Collection Mary S. Myers

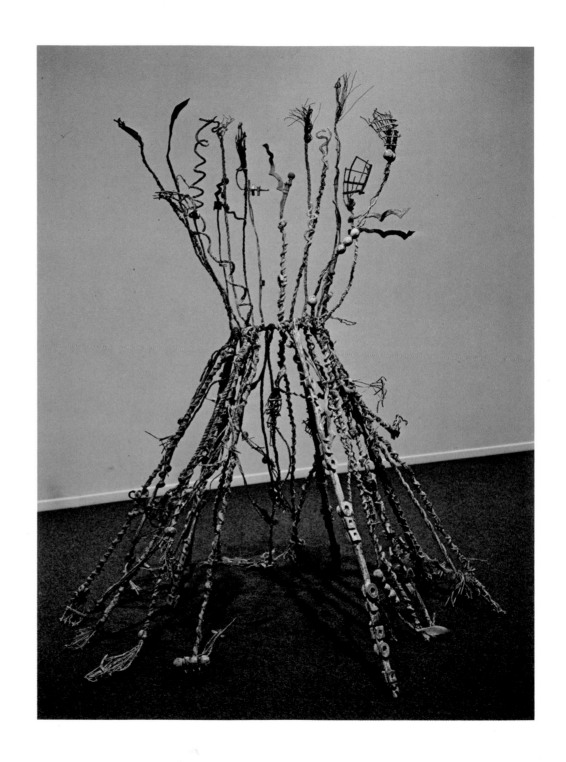

54
**Quipu,** 1978
polychrome bronze
70 x 60 x 58
Helen Elizabeth Hill Trust, Houston, Texas

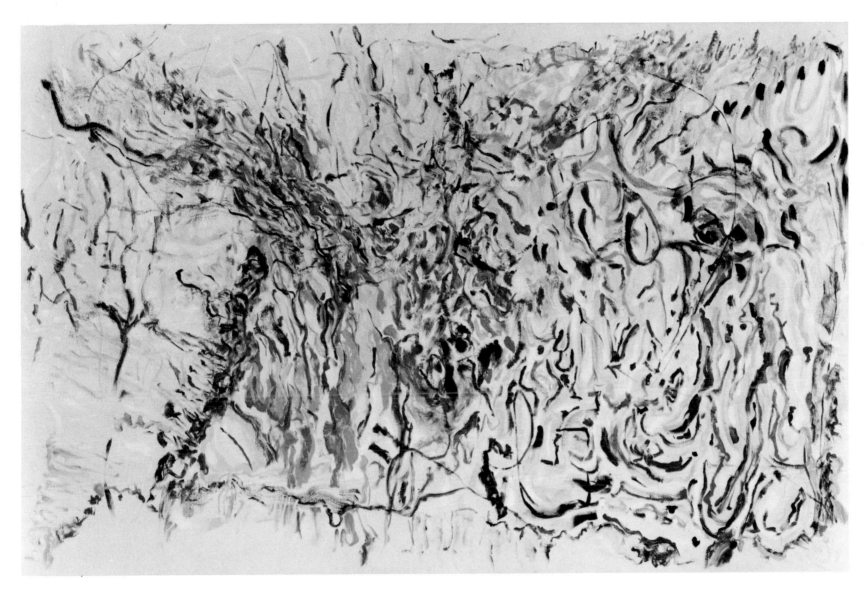

55
**Pkoeth,** 1978
oil on canvas
60 x 90
Collection Dr. and Mrs. Charles Schneider

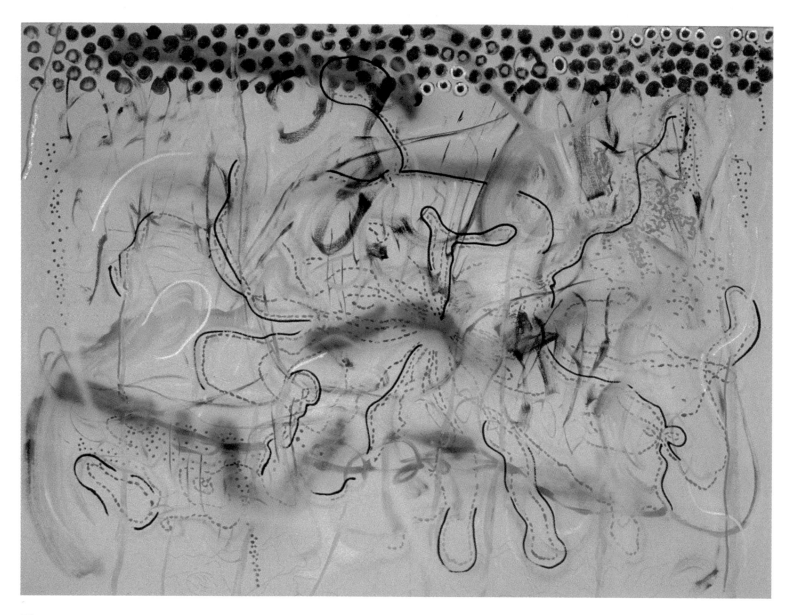

56
**Screen,** 1978
oil on canvas
64 x 84
Collection Mr. and Mrs. Norman Braman

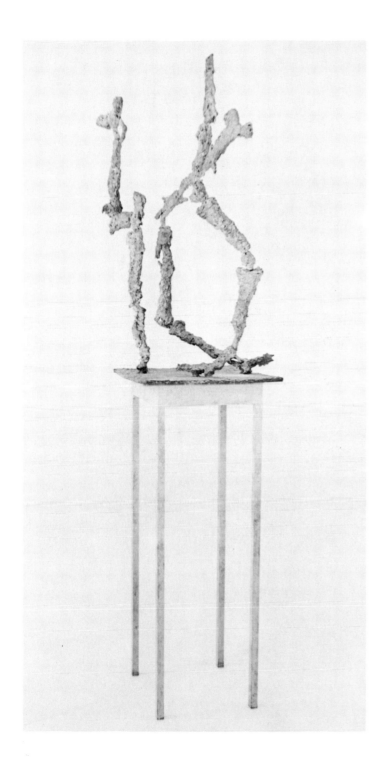

57
**Seven Legs,** 1978
polychrome bronze
69½ x 16 x 22
Courtesy M. Knoedler & Co., Inc., New York

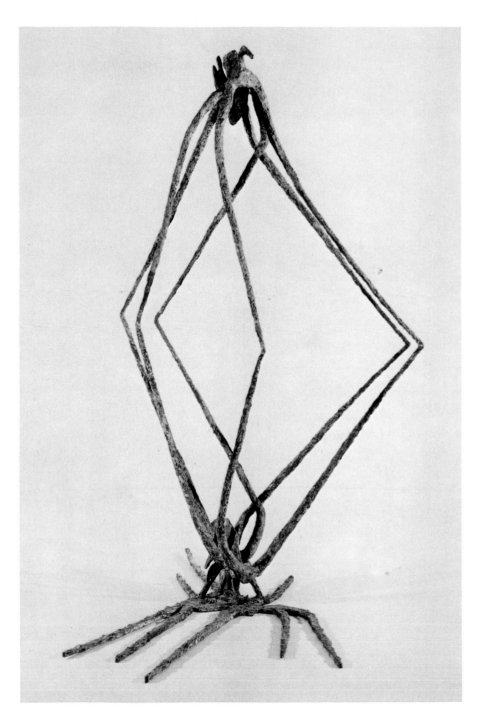

58
**Shadow/Reflection,** 1978
polychrome bronze
57¾ x 52 x 34
Collection Joel and Paula Friedland

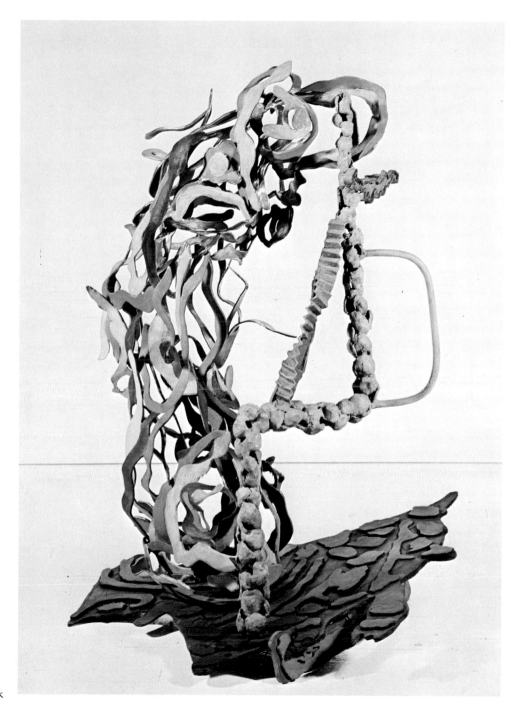

59
**Archaeoloci,** 1979
polychrome bronze and oil
39½ x 30 x 27
Courtesy M. Knoedler & Co., Inc., New York

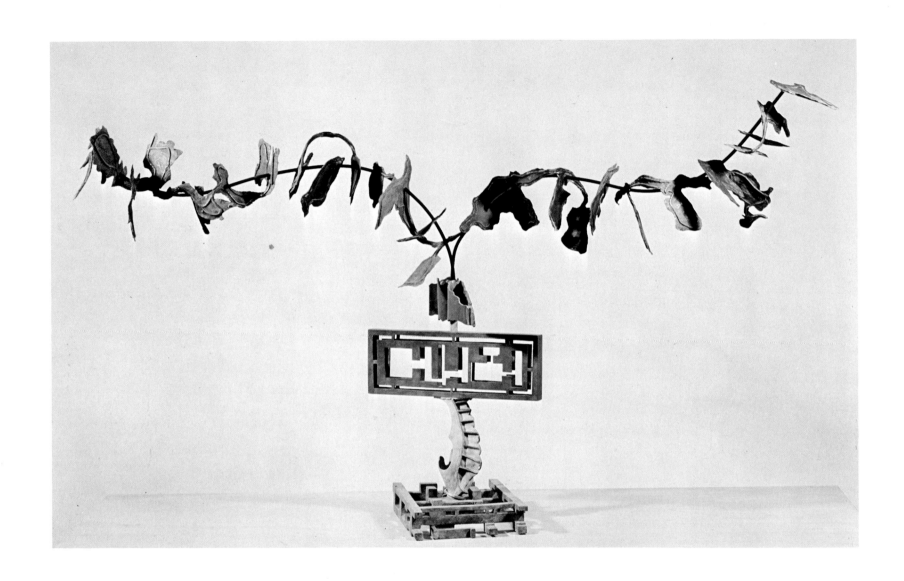

60
**Aves,** 1979
polychrome bronze
46½ x 82 x 30
Collection of the artist

61
**Calibrate,** 1979
acrylic and oil on canvas
64 x 72
Collection Mr. and Mrs. Mark Lederman, New York

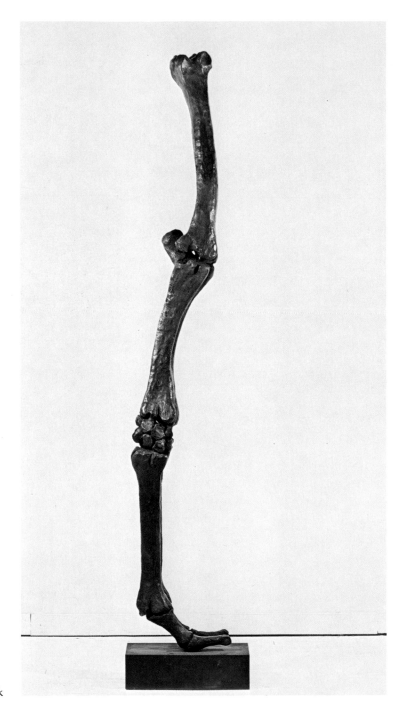

63
**Column,** 1979
bronze
72½ (base: 4 x 6½ x 14)
Courtesy M. Knoedler & Co., Inc., New York

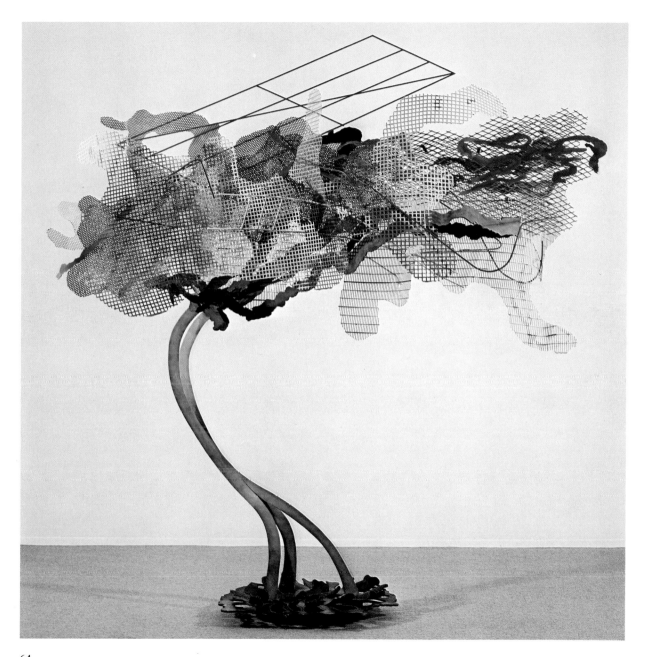

64
**Trace,** 1980
polychrome bronze, steel and oil
107 x 115 x 50
Collection Mr. Graham Gund, Boston

# Exhibitions and Reviews

## One-Artist Exhibitions

1964   The Berkshire Museum, Pittsfield, Massachusetts.
*Nancy Graves: Recent Work,*
December 1 - 31.
Mukherjee, Sushil. "Nancy Graves Exhibit at the Museum."
*The Berkshire Eagle* (Pittsfield), December 12, 1964, p. 4.

1968   Graham Gallery, New York.
*Nancy Graves: Camels,*
April 6 - May 4.
Battcock, Gregory. "art: Camels Today." *The New York Times*
(New York), p. 8.
Glueck, Grace. "You Can Almost See Bedouins." *The New York
Times* (New York), March 13, 1968, Section 2, p. 32.

1969   Whitney Museum of American Art, New York.
*Nancy Graves: Camels,*
March 24 - April 30.
Brochure text by Marcia Tucker and statement by the artist,
"Art." *The Village Voice* (New York), April 3, 1969, p. 21.
"The Camel as Art." *Time* (New York), April 4, 1969, p. 70.
Frankenstein, Alfred. "Eight Odorless Camels." *San Franciso
Sunday Examiner & Chronicle* (San Francisco), April 6, 1969,
p. 39.

1971   Gallery Reese Palley, New York.
*Nancy Graves,*
January 9 - February 3.
Perreault, John. "Camels." *The Village Voice* (New York),
February 4, 1971, pp. 13-14.

National Gallery of Canada, Ottawa.
*Shaman,*
September 2 - October 31.
McCook, Sheila. "Camel lady returns." *The Ottawa Citizen*
(Ottawa), September 3, 1971, p. 29.

Gallery Reese Palley, San Francisco.
*Nancy Graves: sculpture drawings films,*
September 11 - October 16.
Frankenstein, Alfred. "The Lyrical 'Totems' With
Sprouting Forms."

*San Francisco Sunday Examiner & Chronicle* (San Francisco),
September 19, 1971.
Rice, Leland. "Graves Totems." *Artweek* (Oakland, California),
October 2, 1971, p. 2.
Tarshis, Jerome. "Art Shows Are Not Brought By The Stork."
*The San Francisco Fault* (San Francisco).

Neue Galerie der Stadt Aachen, Aachen, West Germany.
*Nancy Graves: Sculpture/Drawings/Films 1969-1971,*
September 25 - November 20.
Unbound catalogue, text by Phyllis Tuchman and interview
by Wolfgang Becker and Michael Strohmeyer. Bound catalogue,
text by Phyllis Tuchman and statements by the artist.

Vassar College Art Gallery, Poughkeepsie, New York.
*Nancy Graves,*
October 17 - November 7.
Rubenstein, Erica B. "Nancy Graves Exhibition Illustrates
Imagination." *Poughkeepsie Journal* (Poughkeepsie), October 24,
1971.

1971-   The Museum of Modern Art, New York.
1972   *Projects: Nancy Graves,*
December 15, 1971 - January 24, 1972 (paintings);
December 15, 1971 - February 7, 1972 (sculpture).
Schjeldahl, Peter. "From Stuffed Camels to Clam Shells."
*The New York Times* (New York), December 26, 1971, p. D-25.
Perreault, John. "Reports, forecasts, surprises and prizes."
*The Village Voice* (New York), January 6, 1972, p. 21.
Rose, Barbara. "The Return of the Image." *New York*
(New York), January 17, 1972, vol. 5, no. 3, p. 50.
Borden, Lizzie. "Nancy Graves." *Artforum* (New York), vol. X,
no. 6, February 1972, p. 90.
Schwartz, Barbara. "Letter from New York: Nancy Graves."
*Craft Horizons* (New York), vol. XXXII, no. 2, April 1972, p. 57.

1972   The New Gallery, Cleveland.
*Nancy Graves: Sculpture, Paintings, Drawings, Films,*
May 19 - June 15.
Sundell, Michael. "Nancy Graves at the New Gallery."
*Cleveland Magazine* (Cleveland), June 1972, pp. 76-77.

Institute of Contemporary Art of the University
of Pennsylvania, Philadelphia (in collaboration with
Contemporary Arts Center, Cincinnati, Ohio,
where it was shown December 1, 1972 - January 7, 1973).

*Nancy Graves: Sculpture and Drawings 1970-1972,*
September 22 - November 1.
Catalogue texts by Yvonne Rainer and Martin Cassidy.
Stadnick, Tom. "Graves exhibit 'lusty and exotic'!."
*Pennsylvania Voice* (Philadelphia), September 20, 1972.
Donohue, Victoria. "Nancy Graves and 'Dem Bones." *The Philadelphia Inquirer* (Philadelphia), September 24, 1972, p. 8-H.
Forman, Nessa. "And It All Began With the Camel." *The Sunday Bulletin* (Philadelphia), September 24, 1972, section 5.
Gross, Michael Stephen. "Beautification of the Bizarre." *34th Street* (Philadelphia), vol. 5, no. 15, September 28, 1972.
Serber, John. "The Rough Beasts of Nancy Graves." *The Drummer* (Philadelphia), October 26, 1972, pp. 15-16.
Adams, Eleanor. "CAC Show Artists Channels Energy Toward the Untried." *The Cincinnati Inquirer* (Cincinnati), November 30, 1972, p. 23.
McCaslin, Walt. "Graves Moves Freely in her Trade." *The Journal Herald* (Dayton, Ohio), December 13, 1972, p. 14.

Janie C. Lee Gallery, Dallas.
*Nancy Graves,*
October 14 - December 8.

1973    National Gallery of Canada, Ottawa.
*Variability and Repetition of Variable Forms by Nancy Graves,*
January 19 - May 27.

The Berkshire Museum, Pittsfield, Massachusetts.
*Recent Works by Nancy Graves,*
May 5 - 31.
Brochure.
Flynn, Anne-Gerard. "Nancy Graves Explains World as She Sees It." *The Berkshire Eagle* (Pittsfield), May 4, 1973, p. 16.
Bell, Winifred. "Nancy Graves at the Museum." *The Berkshire Eagle* (Pittsfield), May 8, 1973, p. 6.

La Jolla Museum of Contemporary Art, La Jolla, California.
*Nancy Graves,*
August 25 - October 7.
Catalogue text by Jay Belloli and statement by the artist.
Traveled to Art Museum of South Texas, Corpus Christi, Texas.
"Space and Ocean Put on Canvas." *The San Diego Union* (San Diego), August 12, 1973, p. E-7.

"La Jolla Exhibit to Honor San Diego." *The Sentinel* (place of publication unknown), August 15, 1973, p. 3-B.
Jennings, Jan. "Graves Show Set to Open." *Evening Tribune* (San Diego), August 24, 1973, p. F-4.
Adler, Sebastian. "Artist Makes Maps Live." *San Diego Union* (San Diego), August 26, 1973.
Seldis, Henry. "From Outer Space. A New Vision of the Self." *Los Angeles Times* (Los Angeles), September 2, 1973.
Kotter, Jennifer. "Kotter Takes on the Dotter." *Reader* (San Diego), September 6 - 12, 1973.
Fish, Mary. "Macrocosmic Mapping." *Artweek* (Oakland, California),September 15, 1973, pp. 1, 16.
Daniels, Fidel. "Nancy Graves and the New Landscape." *Los Angeles Weekly News* (Los Angeles), September 17-21, 1973.

Janie C. Lee Gallery, Dallas.
*Nancy Graves: Satellite Images: drawings and paintings on paper,*
October 13 - November 30.

1974    André Emmerich Gallery, Inc., New York.
*Nancy Graves: New Paintings,*
March 16 - April 3.
Rose, Barbara. "Nancy Graves. Emmerich." *New York* (New York), April 8, 1974, pp. 80-81.
Derfner, Phyllis. "Nancy Graves: André Emmerich Gallery, New York." *Art International* (Lugano), vol. 18, no. 5, May 1974, p. 51.
Bell, Jane. "Nancy Graves: André Emmerich Gallery, New York." *Arts* (New York), vol. 18, no. 9, June 1974, p. 56.
Thomsen, Barbara. "Nancy Graves at Emmerich." *Art in America* (New York), vol. 62, no. 5, September-October 1974, p. 113.

Albright-Knox Art Gallery, Buffalo.
*Nancy Graves: Drawings,*
April 3 - May 5.
Checklist with statement by the artist.
Reeves, Jean. "Camel Consciousness, All That's Seen is Herd." *Buffalo Evening News* (Buffalo), April 4, 1974.

Janie C. Lee Gallery, Houston.
*Nancy Graves,*
May 25 - July 15.
Holmes, Ann. "Nancy Graves' Art Imposing, Dramatic." *Houston Chronicle* (Houston), May 29, 1974, section 6, p. 90.
Moser, Charlotte. "Lunar Landscapes." *The Houston Post* (Houston), June 2, 1974, p. 32.

1975   Janie C. Lee Gallery, Houston.
*Nancy Graves: Recent Paintings and Drawings,*
March 22 - April 30.
Moser, Charlotte. "Graves' Art Makes Concessions." *Houston Chronicle* (Houston), April 9, 1975, section 6, p. 11.

1977   André Emmerich Gallery, Inc., New York.
*Nancy Graves: New Work,*
February 5 - March 2.
Zimmer, William. "Nancy Graves." *The Soho Weekly News* (New York), February 24, 1977, p. 19.
Hess, Thomas B. "Feel of Flying." *New York* (New York), February 28, 1977, pp. 58-60.
Henry, Gerrit. "Nancy Graves: André Emmerich Downtown." *Art News* (New York), vol. 76, no. 4, April 1977, p. 36.
Lubell, Ellen. "Nancy Graves: André Emmerich Downtown." *Arts Magazine* (New York), vol. 51, no. 8, April 1977, p. 36.

Janie C. Lee Gallery, Houston.
*Nancy Graves: New Paintings and Pastels,*
March 5 - May 13.
Moser, Charlotte. "Graves' Carnival — Colored Works Prove Unique." *Houston Chronicle* (Houston), March 12, 1977, section 2, p. 6.
Crossley, Mimi. "Exhibit of Advanced Abstractions." *The Houston Post* (Houston), March 13, 1977, p. 26.

Galerie André Emmerich, Zurich.
*Nancy Graves: New Paintings and Works on Paper,*
July 1 - August 27.
Brochure.
V. H. "Wandlungen der Nancy Graves." Neue Zürcher Nachrichten (Zurich), nr. 197, August 25, 1977.
"The Evolution of Nancy Graves: New Work at the André Emmerich Gallery, Zurich." *New Zurich News* (Zurich), September 8, 1977.

Getler/Paul Gallery, New York.
*Nancy Graves: New Prints,*
September 9 - 24.
Russell, John. "New Prints by Nancy Graves." *New York Times* (New York), September 16, 1977.

1977-  Galerie Im Schloss, Munich.
1978  *Nancy Graves,*
December 3, 1977 - January 8, 1978.
Peters, Hans Albert. "Nancy Graves under Schlosshofgalerie" *Die Schlosshofgalerie* (Munich), December 1977, n.p.

1978   Hammarskjold Plaza, Sculpture Garden, New York.
*Nancy Graves: New Work,*
February 6 - April 30.
Rubinfien, Leo. "Nancy Graves: Dag Hammarskjold." *Artforum* (New York), vol. XVI, no. 10, Summer 1978, pp. 73-74.

M. Knoedler & Co., Inc., New York.
*Nancy Graves,*
February 18 - March 9.
Checklist.
Hess, Thomas B. "Where Have All the Isms Gone?" *New York* (New York), February 13, 1978, pp. 69-70.
Russell, John. "New Paintings by Nancy Graves." *The New York Times* (New York), February 24, 1978, p. C20.
Ratcliff, Carter. "New York Letter." *Art International* (Lugano), vol. XXII, no. 3, March 1978, pp. 50-54.
Senie, Harriet. "Sculpture on a Modern Plane." *New York Post* (New York), March 4, 1978, p. 17.
Frackman, Noel. "Nancy Graves." *Arts Magazine* (New York), vol. 52, no. 9, May 1978, p. 29.
Schwartz, Ellen. "Nancy Graves: Knoedler." *Art News* (New York), vol. 77, no. 5, May 1978, p. 187.

Gallery Diane Gilson, Seattle.
*Nancy Graves: New Sculpture, Recent Watercolors and Pastels and Etchings,*
September 14 - October 14.
"Nancy Graves." *The Weekly* (Seattle), September 20 - 26, 1978.
Campbell, R. M. "Nancy Graves." *Seattle Post-Intelligence* (Seattle), October 1, 1978, p. p-1.
Tarzan, Deloris, "Graves is Great, Benjamin Bright and Bold." *The Seattle Times* (Seattle), October 4, 1978, p. H1
Berger, David A. "The Gallery Scene: Three Shows of Particular Interest." *Argus* (Seattle), October 6, 1978, p. 11.

Janie C. Lee Gallery, Houston.
*Nancy Graves: Recent Paintings, Watercolors and Sculptures,*
November 11 - December 31.
Moser, Charlotte. "Energy, Spirit in Two Shows." *Houston Chronicle* (Houston), November 15, 1978, section 4, p. 1.
Crossley, Mimi. "Review: Works by Andy Burns, Nancy Graves." *The Houston Post* (Houston), November 24, 1978, p. 9AA.

1979   M. Knoedler & Co., Inc., New York.
*Nancy Graves,*
February 17 - March 8.
Checklist.

Russell, John. "Art: Nancy Graves." *The New York Times*
(New York), February 23, 1979, p. C20.
Lubell, Ellen. "Cutting Out." *Soho Weekly News* (New York),
March 8, 1979.
Perrone, Jeff. "Nancy Graves." *Artforum* (New York),
vol. XVII, no. 9, May 1979, pp. 66-67.

1980    M. Knoedler & Co., Inc., New York.
*Nancy Graves: New Paintings and Sculpture*,
March 8 - 27.
Checklist.
Kramer, Hilton. "Art: Bill Jensen Evokes Tradition,
Individuality." *The New York Times* (New York), March 21, 1980,
p. C19.

## Selected Group Exhibitions

1966    Philadelphia Arts Council Exhibition, Philadelphia.
May.

1967    Purdue University, West Lafayette, Indiana.
*Directions*,
November 1 - 30.

1970    Neue Galerie der Stadt Aachen, Aachen, West Germany.
*Klischee und Antiklischee*,
Opened February 26.

Galerie Ricke, Cologne.
*Zeichnungen amerikanischer Künstler*,
May 15 - June 25.

Galerie Ricke, Cologne.
*Programm III*,
June 26 - September 10.

1970-   Whitney Museum of American Art, New York.
1971    *Annual Exhibition of Contemporary American Sculpture*,
December 12, 1970 - February 7, 1971.
Catalogue.

1971    The School of Visual Arts, New York.
*Eraseable Structures*,
January 25 - March 2.

Corcoran Gallery of Art, Washington, D.C.,
*Depth and Presence*,
May 3 - 30.
Catalogue introduction by Stephen S. Prokopoff.

Whitney Museum of American Art, New York.
*Recent Acquisitions*,
May 27 - June 16.

Albright-Knox Art Gallery, Buffalo.
*¿Kid Stuff?*,
July 25 - September 5.
Catalogue text by Bill Burback.

Städtische Kunsthalle, Dusseldorf.
*Prospect '71 Projection*,
October 8 - 17.

Museum of Contemporary Art, Chicago.
*Six Sculptors*,
October 30 - December 12.
Catalogue text by Stephen S. Prokopoff.

1972 National Gallery of Canada, Ottawa.
*Recent Acquisitions: Prints and Drawings,*
January - February.

Whitney Museum of American Art, New York.
*Annual Exhibition: Contemporary American Painting,*
January 25 - March 19.
Catalogue.

Kunsthaus, Hamburg.
*American Women Artists,*
April 14 - May 14.
Catalogue texts by Lil Picard and Sibylle Niester.

Indianapolis Museum of Art, Indianapolis.
*Painting and Sculpture Today 1972,*
April 26 - June 4.
Catalogue text by Richard L. Warrum.

University Art Museum, University of California, Berkeley.
*Eight New York Painters,*
May 10 - June 25.

Neue Galerie, Kassel.
*Documenta V,*
June 30 - October 8.
Catalogue with numerous texts.

University Art Museum, University of California, Berkeley.
*Drawings.*

1973 Whitney Museum of American Art, New York.
*1973 Biennial Exhibition: Contemporary American Art,*
January - March.
Catalogue.

The New York Cultural Center, New York.
*3D into 2D: Drawing for Sculpture,*
January 19 - March 11.

Phyllis Kind Gallery, Chicago.
*Drawings of the '70s,*
April.

Serpentine Gallery, London.
*Photo-Realism: Paintings, sculpture and prints from the
Ludwig Collection and others,*
April 4 - May 6.
Catalogue text by Lawrence Alloway.
Traveled to Louisiana Museum, Humlebaek, Denmark.

Janie C. Lee Gallery, Dallas.
*Inventory,*
Opened May 12.

Whitney Museum of American Art, New York.
*Drawings 1963 - 1973,*
May 25 - July 22.
Catalogue text by Elke M. Solomon.

Fogg Art Museum, Harvard University,
Cambridge, Massachusetts.
*New American Graphic Art,*
September 12 - October 28, 1973.

1974 Wallraf-Richartz Museum, Cologne.
*Kunst der Sechziger Jahre
Internationale Graphik in Beispielen der sammlung Ludwig, Köln,*
March 21 - April 20.
Catalogue text by Peter Baum.

John F. Kennedy Center for the Performing Arts,
Washington, D.C.
*Art Now '74,*
May 30 - June 16.
Catalogue.

The Art Institute of Chicago, Chicago.
*Seventy-First American Exhibition,*
June 15 - August 11.
Catalogue text by A. James Speyer.

Wallraf-Richartz Museum, Cologne.
*Project '74,*
July 6 - September 8.
Catalogue texts by Dieter Ronte, Evelyn Weiss, Manfred
Schneckenburger, Alfred Schug, Marlis Gruterich,
Wulf Herzogenrath, David A. Ross and Birgit Hein.

1975 Whitney Museum of American Art, Downtown Branch,
New York.
*Sculpture of the '60s: Selections from the Permanent Collection,*
March 12 - April 16.

Rutgers University Art Gallery, New Brunswick, New Jersey.
*A Response to the Environment,*
March 15 - April 26.
Catalogue text by Jeffrey Wechsler.

Vassar College Art Gallery, Poughkeepsie, New York.
*Primitive Presence in the '70s,*
May 5 - 31.
Catalogue, edited by Peter Morrin.

Städtisches Museum, Schloss Morsbroich, Leverkusen,
West Germany.
*USA Zeichnungen 3,*
May 15 - June 29.
Catalogue text by Rolf Wedewer.

Albright-Knox Art Gallery, Buffalo.
*American Art in Upstate New York,*
July 12 - August 25.
Catalogue.
Traveled to Memorial Art Gallery, University of Rochester,
Rochester, New York; Herbert F. Johnson Museum of Art,
Cornell University, Ithaca, New York; Everson Museum of Art
of Onondaga County, Syracuse, New York;
Munson-Williams-Proctor Institute, Utica, New York; Albany
Institute of History and Art, Albany, New York.

Galerie André Emmerich, Zurich.
*New Abstract Work,*
October 18 - November 15.

Janie C. Lee Gallery, Houston.
*Group Show II,*
Opened November 1.

Wallraf-Richartz Museum, Cologne.
*Drawings.*

Whitney Museum of American Art, New York.
*New Acquisitions.*

Sarah Lawrence College, Bronxville, New York.
*Drawings by Women.*

1976    Whitney Museum of American Art, New York.
*200 Years of American Sculpture,*
March 16 - September 26.
Catalogue texts by Norman Feder, Wayne Craven, Tom
Armstrong, Daniel Robbins, Rosalind E. Krauss, Barbara
Haskell and Marcia Tucker.

Corcoran Gallery of Art, Washington, D.C.
*America 1976,*
(commissioned by the United States Department
of the Interior),
April 27 - June 6.
Catalogue texts by Robert Rosenblum, Neil Welliver,
John Ashbery and Richard Howard.
Traveled to Wadsworth Atheneum, Hartford; Fogg Art
Museum, Harvard University, Cambridge, and the Institute of
Contemporary Art, Boston; The Minneapolis Institute of
Arts, Minneapolis; Milwaukee Art Center, Milwaukee;
The Fort Worth Art Museum, Forth Worth; San Francisco
Museum of Modern Art, San Francisco; The High
Museum of Art, Atlanta; The Brooklyn Museum, New York.

Marion Koogler McNay Art Institute, San Antonio, Texas.
*American Artists '76: A Celebration,*
May 23 - July 31.
Catalogue text by Alice C. Simkins and statements
by the artists.

Institute of Contemporary Art, Boston.
*A Selection of American Art: The Skowhegan School 1946-1976,*
June 16 - September 5.
Catalogue texts by Lloyd Goodrich, Bernarda B. Shahn
and Allen Ellenzweig.
Traveled to Colby Museum of Art, Waterville, Maine.

Nationalgalerie, Berlin.
*Amerikanische Kunst von 1945 bis heute,*
September 4 - November 7

The Sewell Gallery, Rice University, Houston.
*Drawing Today in New York,*
(organized by Patricia Hamilton and Check Baters),
October 8 - November 19.
Traveled to Newcomb College, Tulane University,
New Orleans; Southern Methodist University,
Dallas; University Art Museum, University of
Texas at Austin, Austin; Oklahoma Art Center,
Oklahoma City; Dayton Art Institute, Dayton, Ohio

Philadelphia College of Art, Philadelphia.
*Private Notations: Artists' Sketchbooks II,*
October 23 - November 24.
Catalogue text by Janet Kardon.

United States Information Agency, Washington, D.C.
*The Liberation: 14 American Artists,*
(organized by Jane Livingston, Chief Curator, Corcoran
Gallery of Art, Washington, D.C.)
Shown in several European cities throughout 1976-77.
Each institution produced its own catalogue.

1977   Philadelphia College of Art, Philadelphia.
*Artists' Maps,*
January 28 - February 25.
Catalogue text by Janet Kardon.

The Women's Building, Los Angeles.
*Contemporary Issues: Works on Paper by Women,*
February 2 - mid-April.

Künstlerhaus Wien, Vienna.
*Art Around 1970,*
March 8 - June 12.
Catalogue texts by Hans Mayr, Wolfgang Becker,
Kristian Sotriffer, Peter Baum, with an interview
with Peter Ludwig by Wolfgang Becker.

The Emily Lowe Gallery, Hofstra University, Hempstead, New
York.
*Art off the Picture Press: Tyler Graphics Ltd.,*
April 14 - May 22.
Catalogue text by Judith Goldman.

Philadelphia College of Art, Philadelphia.
*Time,*
April 24 - May 21.
Catalogue text by Janet Kardon and statements by the artists.

Kassel, West Germany.
*Documenta 6,*
June 24 - October 2.
Catalogue text by Wieland Schmied.

University Art Museum, University of Texas, Austin.
*New in the Seventies,*
August - September.

Thomas Segal Gallery, Boston.
*Works on Paper,*
August 16 - September 30.

Fine Arts Gallery of San Diego, San Diego.
*Invitational Drawing Show,*
September 17 - October 30.
Catalogue.

New York State Museum, Albany.
*New York: The State of Art,*
October 8 - November 28.
Catalogue texts by Dr. Robert Bishop, Dr. Wilham H. Gerdts
and Thomas B. Hess.

Vancouver Art Gallery, Vancouver.
*Strata,*
October 9 - November 6.
Catalogue text by Lucy R. Lippard.

Joe and Emily Lowe Art Gallery, Syracuse University, Syracuse.
*Critic's Choice,*
November 13 - December 13.
Brochure.
Traveled to Munson-Williams-Proctor Institute, Utica.

University Gallery, Southern Methodist University, Dallas.
*Twelve Contemporary Painters,*
November 15 - December 13.

Kennedy Galleries, New York.
*Artists Salute Skowhegan,*
December 8 - 21.
Catalogue text by Allen Ellenzweig.

1977-   The Madison Art Center, Madison.
1978   *Recent Works on Paper by American Artists,*
(organized by the University of Wisconsin, Madison),
December 4, 1977 - January 15, 1978.
Catalogue.

M. Knoedler & Co., Inc., New York.
*Group Show,*
December 13, 1977 - January 5, 1978.

1978   Teheran Museum of Contemporary Art, Teheran
*The Ludwig Collection,*
(in affiliation with the Shahbanou Farah Foundation),
January.

UCSB Art Museum, University of California, Santa Barbara.
*Contemporary Drawing/New York,*
February 22 - March 26.
Catalogue text by Phyllis Plous.

Thomas Segal Gallery, Boston.
*Water Colors,*
March 11 - April 8.

Whitney Museum of American Art, Downtown Branch,
New York.
*Cartoons,*
May 31 - July 5.

Ray Boyd Gallery, Chicago.
*Group Show: Recent Work,*
September 8 - October 4.

Freedman Gallery, Albright College, Reading, Pennsylvania.
*Perspective '78: Works by Women,*
October 8 - November 15.
Catalogue text by Therese Schwartz.

Toledo Museum of Art, Toledo, Ohio.
*Art for Collectors,*
November 12 - December 17.

Philadelphia College of Art, Philadelphia.
*Point,*
November 20 - December 15.
Catalogue text by Janet Kardon.

1978- Albright-Knox Art Gallery, Buffalo.
1979 *American Painting of the 1970s,*
December 8, 1978 - January 14, 1979.
Catalogue text by Linda L. Cathcart.
Traveled to Newport Harbor Art Museum, Newport Beach,
California; The Oakland Museum, Oakland, California;
Cincinnati Art Museum, Cincinnati, Ohio; Art Museum of
South Texas, Corpus Christi; Krannert Art Museum, University
of Illinois, Champagne.

1979 Julian Pretto, New York.
*Atypical Works,*
January 4 - 31.

Seagram Building, New York.
*Contemporary Landscape,*
February 9 - April 26.

Henry Street Settlement, The Louis Abrons Arts for
Living Center, New York.
*Exchanges I,*
May 11 - June 8.
Catalogue texts by Renata Karlin and Lucy R. Lippard.

American Academy in Rome, Rome.
*Annual Exhibition,*
May 22 - June 10.
Catalogue.

The Williams College Museum of Art,
Williamstown, Massachusetts.
*Documents, Drawings and Collages,*
June 8 - July 5.
Catalogue texts by Stephen D. Paine, Franklin W. Kelly,
Stephen Eisenman, Hiram Caruthers Butler.

The Grey Art Gallery and Study Center,
New York University, New York.
*American Painting: The Eighties,*
September 5 - October 13.
Catalogue text by Barbara Rose and statements by artists.
Traveled to Contemporary Arts Museum, Houston.

Trisolini Gallery, Ohio University, Athens, Ohio.
*Seven Artists at Tyler Graphics Ltd.,*
September 10 - October 6.
Catalogue text by Donald Harvey.
Traveled to Gallery II, Western Michigan University,
Kalamazoo, Michigan; University Galleries, University of
Akron, Akron, Ohio; Decker Gallery, Maryland Institute of Art,
Baltimore.

The Hudson River Museum, Yonkers, New York.
*Super Show,*
(organized by Independent Curators Inc.),
October 21 - December 9.
Traveled to Landmark Center, St. Paul, Minnesota;
Center for the Fine Arts, Mesa, Arizona.

1979- Kunsthaus Zurich, Zurich.
1980 *Weich und Plastisch,*
November 16, 1979 - February 4, 1980.
Catalogue texts by Willy Rotzler, Erika Billeter, Andre
Thomkins, Mildred Constantine, François Lupu, Anne
Dupuis, Magdalena Abakanowicz, Richard Paul Lohse,
and interview with Klaus Rinke by Erika Billeter.

Institute of Contemporary Art of the University of
Pennsylvania, Philadelphia.
*Masks, Tents, Vessels and Talismans,*
December 5, 1979 - January 13, 1980.
Catalogue text by Janet Kardon.

1980 M. Knoedler & Co., Inc., New York.
*Group Show,*
January 5 - 24.
Checklist.

# Articles

1970 Wasserman, Emily. "A Conversation with Nancy Graves." *Artforum* (New York), vol. IX, no. 2, October 1970, pp. 42-47.

1971 Davis, Douglas. "The Invisible Woman is Visible." *Newsweek* (New York), vol. LXXVIII, no. 20, November 15, 1971, pp. 130-131.

Keefe, Nancy Q. "Nancy Graves." *The Berkshire Eagle* (Pittsfield, Massachusetts), January 29, 1971, p. 5.

1972 Chandler, John Noel. "notes towards a new aesthetic." *Artscanada* (Toronto), vol. XXIX, no. 4, Issue Nos. 172/173, October /November 1972, pp. 16-41.

Richardson, Brenda. "Nancy Graves: A New Way of Seeing." *Arts Magazine* (New York), vol. 46, no. 6, April 1972, pp. 57-61.

Rose, Barbara. "Living the Loft Life." *Vogue* (New York), August 1, 1972, pp. 72-75, 124.

1973 Kalavinka, Mia. "6 Brain Maps." *Artscanada* (Toronto), vol. XXX, no. 2. Issue Nos. 178/179, May 1973, pp. 50-55.

1974 Arn, Robert. "The Moving Eye . . . Nancy Graves Sculpture, Film and Painting." *Artscanada* (Toronto), vol. XXXI, no. 1, Issue Nos. 188/189 Spring 1974, pp. 42-48.

Channin, Richard. "Nancy Graves: Map Paintings." *Art International* (Lugano), vol. 18, no. 9, November 15, 1974, pp. 26-27, 62.

1975 Channin, Richard. "Facture and Information: Nancy Graves Antarctica Paintings." *Arts Magazine* (New York), vol. 50, no. 2, October 1975, pp. 80-82.

Kozloff, Max. "Remarks on Their Medium By Four Painters: Pat Adams, Nancy Graves, Budd Hopkins, Irving Petlin." *Artforum* (New York), vol. XIV, no. 1, September 1975, pp. 55-62.

Lippard, Lucy R. "Distancing: The Films of Nancy Graves." *Art in America* (New York), vol. 63, no. 6, November-December 1975, pp. 78-82.

1976 Hill, Lafe. "The Greening of Greenwich Village." *Viva* (New York), September 1976, vol. 3, no. 12, pp. 60-65.

Bannon, Anthony. "Albright-Knox Adds to Collection." *Buffalo Evening News* (Buffalo), December 31, 1976.

1977 Heinemann, Susan. "Nancy Graves: The Paintings Seen." *Arts Magazine* (New York), Vol. 51, no. 7, March 1977, pp. 139-141.

Rose, Barbara. "Sudden confidence: women are making art history . . ." *Vogue* (New York), June 1977, pp. 152, 189, 193.

1979 Russell, John. "Art People." *The New York Times* (New York), January 26, 1979, p. C16.

## Public Collections

Aachen,West Germany, Neue Galerie im Alten Kurhaus
Berkeley, California, University Art Museum
Buffalo, New York, Albright-Knox Art Gallery
Chicago, The Art Institute of Chicago
Cologne, Wallraf-Richartz Museum, Ludwig Collection
Corpus Christi, Texas, Art Museum of South Texas
Des Moines, Iowa, Des Moines Art Center
Houston, The Museum of Fine Arts
La Jolla, California, La Jolla Museum of Contemporary Art
Memphis, Tennessee, Brooks Memorial Art Gallery
New Haven, Connecticut, Yale University Art Gallery
New York, The Metropolitan Museum of Art
New York, The Museum of Modern Art
New York, Whitney Museum of American Art
Ottawa, National Gallery of Canada
Poughkeepsie, New York, Vassar College Art Gallery
Vienna, Museum des 20. Jahrhunderts

# Photographic Credits

COLOR

Courtesy of the artist: Cat. nos. 18, 32, 48, 51.
Courtesy Dallas Museum of Fine Arts: Cat. no. 29.
Kevin Henke, courtesy Janie C. Lee Gallery, Houston: Cat. no. 54.
Jerry Huth, St. Louis: Cat. no. 8
Courtesy M. Knoedler & Co., Inc., New York: Cat. nos. 59, 60, 61, 62, 63, 64.
Courtesy Janie C. Lee Gallery, Dallas: Cat. no. 14.
Courtesy Janie C. Lee Gallery, Houston: Cat. nos. 20, 25, 34.
Ann Münchow, Aachen, West Germany: Cat. no. 7.
Eric Pollitzer, New York: Cat. nos. 1, 6, 31.
Photo Shunk-Kender, New York: Cat. no. 16.

BLACK AND WHITE

Courtesy of the artist: Cat. nos. 11, 12, 13, 57.
Charlotte Brooks: Cat. no. 49.
Greenberg-May Prod., Inc.: Cat. no. 24.
Courtesy M. Knoedler & Co., Inc., New York: Cat. nos. 9, 46, 50, 52, 55, 58. Fig. nos. 12, 13.
Peter Moore, New York: Cat. nos. 2, 3, 4, 5.   Fig. nos. 2, 3, 7, 9.
The National Gallery of Canada, Ottawa: Fig. no. 1.
Phototech Studio, Buffalo, New York: Cat. no. 40.
Eric Pollitzer, New York: Cat. nos. 21, 22, 23, 27, 28, 33, 35, 36.   Fig. nos. 10, 11.
Photo Harry Shunk, New York: Cat. no. 10.
Photo Shunk-Kender, New York: Cat. nos. 15, 17, 26.
Steven Sloman Fine Arts Photography: Cat. no. 39.
Photograph of Nancy Graves filming on location by David Anderson.

4,000 copies of this catalogue, edited by Josephine Novak and designed by Bud Jacobs have been typeset in Palatino and printed on Cameo Dull #100 by Harry Hoffman and Sons, Inc. Printing, Buffalo, New York, on the occasion of the exhibition *Nancy Graves: A Survey 1969/1980*, May 1980.